Chardin and the Still-Life Tradition in France

Published by The Cleveland Museum of Art

Chardin and the Still-Life Tradition in France

Gabriel P. Weisberg
with William S. Talbot

Published with the support of the National Endowment for the Arts

The color cover is a detail of *Still Life with Copper Cauldron* by Antoine Vollon [32].

The title page is a detail of *Still Life with Bread and Eggs* by Paul Cézanne (Figure 29).

Distributed by Indiana University Press, Bloomington, Indiana 47401

Contents

Lenders to the Exhibition

The Art Institute of Chicago
Mr. and Mrs. Noah L. Butkin, Cleveland, Ohio
The Cleveland Museum of Art
Musée Carnavalet, Paris
Musée du Louvre, Paris
Petit Palais, Paris
Mr. and Mrs. Henry Scherer, Jr., Avon, Connecticut
The Toledo Museum of Art
Wadsworth Atheneum

Acknowledgments

The authors would like to thank the following individuals: John W. McCoubrey for his perceptive opening remarks; Mr. and Mrs. Noah L. Butkin; The Schickman Gallery, New York; Mme. Adéline Cacan de Bissy, Musée du Petit Palais, Paris; Michel Laclotte, Musée du Louvre, Paris; Dr. and Mrs. Sherman E. Lee; Mr. and Mrs. Henry Scherer, Jr.; Bernard de Montgolfier, Musée Carnavalet, Paris; Joseph Baillio, New York; Hsio-Yen Shih, The National Gallery of Canada; Phillip Johnston, Wadsworth Atheneum; Roger Mandle, The Toledo Museum of Art; J. Patrice Marandel, The Art Institute of Chicago; Joy Walworth.

Boldface numbers in brackets [5] refer to catalog numbers in the exhibition. The small superscript numbers refer the reader to sources or additional commentary that are listed at the end of each section.

Full information on the catalog illustrations is given in the catalog section which begins on page 89. Full information on the figure illustrations begins on page 91.

Foreword

In the centuries after the Renaissance, still-life painting in the official view led a marginal existence. Those who produced it were relegated to the role of minor artists and their subject matter deemed incapable of intellectual interest or moral instruction, useful only to display an artist's skill in the imitation of insignificant objects. It would have surprised the ancient Greeks to see the rediscovery of their ideal of beauty and harmony of proportion used as a weapon to maintain this state of suppression. Had not Zeuxis and Parrhasios, at a time when this ideal was first being formed in ancient Greece, chosen to match their skill through still-life painting? In this contest, according to the story which was quite familiar to the modern guardians of propriety, Zeuxis painted some grapes so lifelike that birds came to peck at them, but he lost the contest when he stepped forward to remove what he thought was a cloth drapery covering his rival's work only to discover to his dismay that the cloth *was* the painting. Science may have changed the opinion which gave the contest to Parrhasios — that it was easier to fool birds than men — but there was no doubt that imitation was the criterion of judgment.

This charming story of still-life painting reminds us of its presence even at a moment of high aspiration in Greek art and of its continued survival in the painting of western Europe. In matching their skills by painting some grapes and a cloth, the contestants chose to be judged on the very basis of the painter's art: the ability to render the illusion of a three-dimensional object on a two-dimensional surface, and they did it with still life, which reveals that skill most nakedly exposed to judgment. The issue was not how beautiful and fresh the grapes appeared to be or how beautifully woven the cloth. Zeuxis's misguided attempt to remove Parrhasios's painted cloth, and the latter's canny choice of that deception, reflects rather the insistent, intimate appeal of still life that invites the viewer to enter a world painted to his scale and full of objects which, in their familiarity, awaken his sense of taste, even smell, and, in Zeuxis's case, touch. Despite pedants of theory and propagandists of church or state, that simple — or perhaps not so simple — appeal guaranteed the continuity of still life as long as some degree of naturalism remained the norm in painting.

With the exception of the masters of still life in seventeenth-century Holland — who are often, as painters of still life, only "little masters" — most of its practitioners are known only to scholars and much that survives is from unknown hands. These little-known or forgotten artists worked at all levels of society, providing decoration to hang over a doorway or to adorn a fire screen. Much of what they made was that most unassuming-of-all painting, intended, like the rival curtain, to fool the eye — painting which may be said to succeed best when it passes unrecognized as art at all. Such were the paintings in imitation of carved relief or, at the other end of the social scale, shoes painted on a box bed to appear as though they were placed on the floor under it. We know of such painting from texts, through anonymous works, or those by some of the ack-

nowledged masters of the art, like Oudry or Chardin himself who were happily rescued from the relative obscurity of a public exhibition on the Place Dauphine in Paris by a member of the Royal Academy.

The paintings collected here attest to the vitality of still life in France even though its painters were there kept in low estate and excluded from the higher ranks of the still-powerful Royal Academy. Although in the eighteenth century a variety of themes (like attributes of the arts, the seasons, and even the four elements) lent a spurious academic propriety to many still lifes, a growing number of men of taste began to value the painting of inanimate objects for its own sake. As such painting attracted new connoisseurs, it also began to regain its other life as painters' painting, close to the preoccupations and lore of the studio. Oudry painted a white duck with other white and off-white objects to display and sharpen his ability to distinguish among objects so colored and their reflections. Desportes may have been challenging the alleged superiority of sculpture over painting when he painted fruit so reflected in silverware that all sides of it were shown simultaneously, as Giorgione had done over two centuries earlier, using a similar device in the painting of the human figure. In the ateliers, "Titian's bunch of grapes" was a term both for the management of light and shade and for exercises in that skill. It is part of Chardin's greatness that he shunned such *tours de force* by his contemporaries and, for the most part, attempted to "elevate" his subjects. In remaining faithful to a few humble objects, he democratized still life, made it accessible to a wider range of admirers — quieting it, so to speak, to let its appeal work more slowly and deeply on the sensibilities of his growing number of admirers.

As one learns more about still life through exhibitions such as this, its constant presence through history becomes apparent, and the fulminations of critics and theorists more and more suspect. It reminds us of how little we really know of what, in the best sense of the term, may be called popular art. At least five still lifes hung in the chambers of the Royal Academy in the eighteenth century. In 1809 the influential dealer Lebrun was recommending the purchase of Chardins when neoclassicism was still much in vogue. Even the proscriptive guardian of that doctrine, the formidable J. A. D. Ingres, was, as Gabriel Weisberg informs us, upset when he lost an opportunity to buy a Chardin, revealing, thereby, a private taste no different from that of his arch rival Delacroix who openly proclaimed his admiration by doing a painting after a Chardin. With the Realists of the mid-century, the hierarchy of subject matter collapsed. The private patron of modest means became a greater force in the market, buying still lifes by contemporaries and looking for the odd bargain from the eighteenth century. One should not be surprised to learn that some of the most impressive collections of still life were formed by amateur painters. By the time of the Impressionists, nearly equal value was placed on still life, landscape, and the figure — and Manet, Monet, Bazille, Sisley, and others were painting dead game based directly on Chardin or with a high seriousness they had learned from him. If such facts refer to the continual popularity of this painter's painting, another story told of a bunch of asparagus by Manet touches upon its ancient appeal as imitation. Finding himself overpaid for his modest work, Manet, like an honest grocer, obliged the generous purchaser with another painting of a single stalk. Zeuxis and Parrhasios would have understood this light-hearted play on the painted object as the object itself. Diderot, Chardin's contemporary and baffled-but-admiring critic, would have approved of the revaluation of still life in the nineteenth century. The problems of painting a scene however vast, were, he wrote, present in those rendering a single grape.

John McCoubrey
University of Pennsylvania

Settings Pervaded with Stillness

Whether Chardin can be called the father of modern still-life painting is open to further study,[1] but without a doubt he was among the first to recognize that by painting specific objects — those observed directly from nature — an artist could not only achieve a standard of painting excellence but also paint intuitively.[2]

At a time when few other still-life painters received recognition at the annual Salon exhibitions in Paris, Chardin was accepted with enthusiasm by the jury and the public, and was afforded the faithful support of the French philosopher and critic Denis Diderot.[3] It was Diderot who recognized in Chardin's later still lifes the mastery of illusionistic technique and individuality of approach that made his still lifes unique.[4] In reviewing the still lifes that Chardin exhibited in 1763 and 1765, Diderot analyzed Chardin's formalistic method of composing images within carefully handled space and color relationships, achieving subtle color harmony and providing atmosphere in which to place his inanimate objects.[5] In part, from Chardin's work, Diderot developed a theory of pure painting — an aesthetic of visual stimulation — that emphasized the importance of Chardin in his own time and prepared a foundation for the study of Chardin's work that would benefit future still-life painters.

It had been established in the French tradition of the arts that those still-life painters who wished to qualify for the annual Salons and who wished to be considered successful were restricted to several categories. Those who carefully arranged their objects could depict (1) large, ex-otic, decorative compositions of fruit and flowers; (2) illusionistic devices that attempted reality by specific representation; or (3) small, unpretentious studies of everyday objects within household settings.

Needless to say, the works of Chardin which most affected the later nineteenth-century revival of still-life painting were those which were the least pretentious — household interiors and everyday objects.[6] These compositions by Chardin — as much as other Dutch, Flemish, and French examples from the seventeenth and eighteenth centuries — also led later artists to create a wide variety of still-life categories.[7]

THE STILL-LIFE TRADITION

During the seventeenth century and at the time Chardin received his formal artistic training, only paintings within a hierarchy that met a rigidly defined and enforced set of standards were eligible for consideration at the annual Salons. This hierarchy of art, which had been explained by the architect and writer André Félibien (1619-1695), ranked historical themes as the highest artistic achievement and relegated the still life to the lowest level that was considered eligible.[8] As Félibien explained it, the human body was the most perfect work of God on earth,[9] and, therefore, man — and images of the ennobled individual from the past who could serve as a model for contemporary humanity — was the center of artistic achievement. Because still life was limited to the arrangement of objects

9

or ornaments, it was of lesser value. It depicted less of man's life,[10] less of his ingenuity. The hierarchy was not only applicable to the already established "works of art" (e.g., Nicolas Poussin's *Shepherds of Arcadia*) but reasonable, too, in an age that was eager for rules and formalistic methods, and it was readily sanctioned by the Salon jury and easily and effectively perpetuated by the then-successful artists, their critics, and the public. The hierarchy and the desire to achieve the foremost rank — as a painter of history — contributed to lack of regard for individual tendencies and experimentation with new themes.

It is not surprising that the still-life painter was thus considered a craftsman — a copyist — whose skill permitted him to master only the lowly task of depicting fruits and flowers.[11] As a result, during the seventeenth century and well into the eighteenth, the number of French painters who devoted their careers to the creation of still life was never large. In general, it was concluded that the "still-life painter was forever condemned to expend a meager talent on worthless subjects."[12]

Since the still life could not encompass the high ideals of man, God, or state, the only acceptable innovations to appear in still-life compositions were objects from antiquity and *memento mori* (reminders of death or mortality) that conveyed classical ideals or showed a relationship with the glories of the past, such as busts and sculpture. Their introduction led to the gradual lessening of the restrictions within this lowest level of art and to the evolution of a new aesthetic in still-life painting based on visual perception rather than strict moralistic values. These changes within the still life as a composition were largely the result of the independent tendencies of Chardin.

Inherent in the tradition of still-life painting, and observed as well by Chardin, were a variety of categories. Just as painters of other types of art acknowledged the growing popularity of hunt scenes and the increasing interest in Flemish scenes, still-life painters were also attracted to these images. Popular still-life categories included: (1) the buffet — lavish displays of flowers and fruit combined with expensive, ornate tableware; (2) trophies of the hunt — dead game; (3) allegorical images — frequently of the four seasons; (4) domestic interiors featuring a buffet; (5) room decorations; (6) studies of meal preparation; or (7) arrangements of objects symbolizing the arts or the sciences.[13]

In several of these categories, such as images of the hunt (dead game), Chardin and other still-life artists studied ordinary objects placed within a simplified setting. Often the "deadness" of the animal or wildfowl was contrasted with the vibrancy of the color and the texture of the skin or fur. Perhaps the most important category — and one area that Chardin revolutionized — was the kitchen interior.[14] Here, there was no attempt to create an elaborate setting. Instead, artists tried to reveal the physical nature of the objects they were observing. These compositions were often small and unpretentious — and may not always have qualified for Salon exhibition. Nevertheless, such studies of familiar objects appealed to the newly rich middle class. Indeed, the middle class became the new patrons of the still life,[15] because these smaller paintings satisfied their desire for impressive original works of art that were appropriate for their apartments. In general, the traditional categories were the foundation from which all still-life painters learned their crafts. It is important to note, also, that it was Chardin's ingenious mastery of many of these traditional categories — his own inventiveness and perception — that had a far-reaching effect upon later artists, especially those in the nineteenth century, providing them with a model to follow in the construction of their own images.

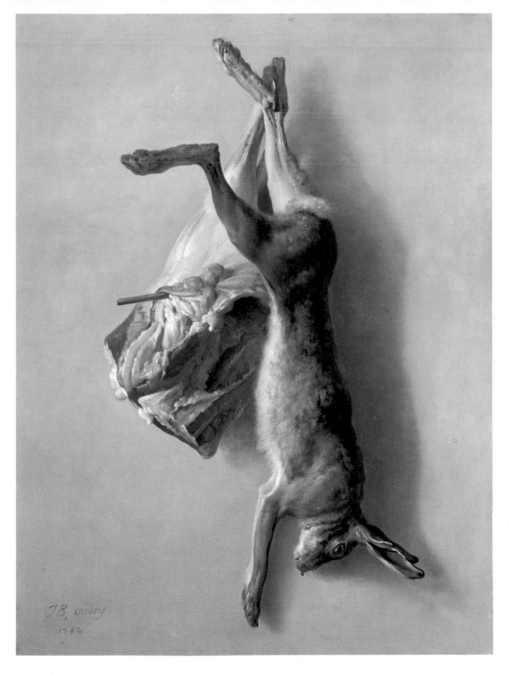

5 Jean Baptiste Oudry,
Hare and Leg of Lamb.

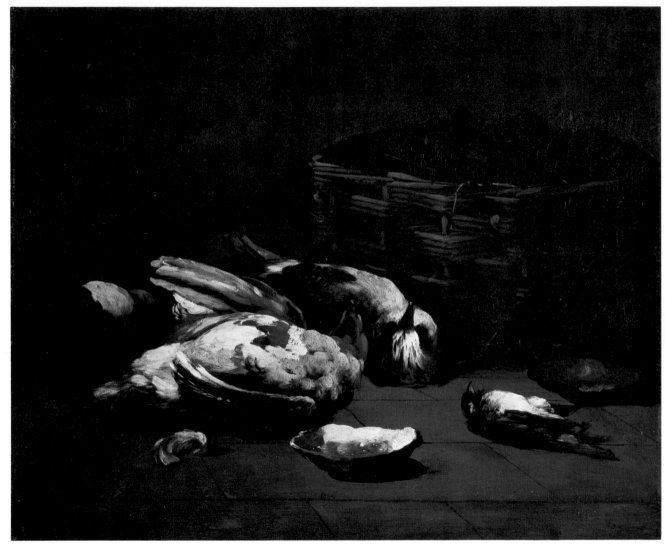

24 Germain Ribot, *Oysters and Partridges*.

Opposite **8** Joseph Bail, *Still Life* (detail).

CHARDIN AS MODEL

During the eighteenth century, with Diderot as his champion, Chardin reigned over the creation of still life. Other artists were overshadowed by what he accomplished; rival painters such as Jean Baptiste Oudry [5] or Henri Horace Roland de la Porte [6] were subsumed by his originality. By the nineteenth century, Chardin's works were seen as pursuits of visual truth.

In many of his later works (e.g., *Preparations for Lunch,* 1763; *A Green-Neck Duck . . . ,* 1765), Chardin constructed images from familiar, everyday objects.[16] The Salon tradition of painting lavish containers or exotic fruits was minimized, for he selected objects to convey a human touch — objects that had a definite functional purpose in a human environment. In a sense, Chardin humanized still life, extricating it from a study of overly precious objects or examples weighted with classical references and making of it, instead, the careful consideration of common ceramic bowls or ordinary fruit. This characteristic was the most significant factor affecting critics, collectors, and artists when his paintings were rediscovered during the nineteenth century.

Chardin's still lifes can also be appreciated in another way — as purely sensory stimulation. His works were, in part, visual examinations of the shapes before him. When he created his canvases, Chardin responded to what he saw personally and directly, allowing his visual sensations to predominate.[17] This was a new, a natural, and a simple way of painting that resulted in his deification during the Realist revival of the following century.

Chardin made the still life an important vehicle of personal expression and "compelling familiarity."[18] His ability to establish still life as an independent category prepared the way for the abolition of the hierarchy of themes which had dominated the Salon. Admired and acclaimed during the eighteenth century, he later became a model for critics, collectors, and painters when his significance was slowly rediscovered during the nineteenth century, when he was again recognized for his ability to use geometric constructions, muted tones, and illumination within a self-contained composition to render the essential nature as well as the visual description of familiar objects.

1. Chardin has been regarded as the most impressive still-life painter of the modern movement. For a discussion of his work and influence, see Pierre Rosenberg, *Chardin,* exh. cat. (Paris: Editions de la Réunion des Musées Nationaux, 1979). The legacy of Chardin, in linking Dutch still-life painters of the seventeenth century and the French artists of the still-life revival of the nineteenth century, was noted by Stephen S. Kayser, "The Revolution of Still Life," *Pacific Art Review* I, no. 2 (1941): 20. John McCoubrey, in his pioneering doctoral dissertation, examined Chardin in the context of the still-life tradition and as part of the theory and art criticism of several centuries. See John W. McCoubrey, *Studies in French Still-Life Painting, Theory and Criticism: 1660-1860* (Ph.D. diss., New York University, March 1958; Ann Arbor, Mich.: University Microfilms, MIC58-7755).

Pierre Rosenberg revealed that the true name of Chardin was Jean Siméon Chardin and not Jean-Baptiste Siméon Chardin as numerous earlier writers had assumed; see *Chardin,* pp. 63, 66, 382, 406-7.

An open debate remains about when the first modern still life was painted. For reference see Charles de Tolnay, "Les Origines de *La Nature Morte Moderne,*" *Revue des Arts,* no. 3 (1952): 151-52. Some writers have defined still life as "nature being rearranged by the artist"

31 Antoine Vollon, *Monkey Cook* (detail).

and have tried to find the significance of many examples from differing periods. See Kayser, "Revolution of Still Life," pp. 16-28; A. Everett Austin, Jr., and Henry Russell Hitchcock, Jr., "Aesthetic of the Still Life over Four Centuries," *ArtNews* 36 (February 1938): 12-13, 23-24. For a survey of French still-life painting, see Michael Faré, *La Nature Morte en France,* 2 vols. (Geneva: Pierre Cailler, 1962).

2. McCoubrey, *Studies in French,* p. 74. Chardin's standard of excellence was first detected by the critic Denis Diderot.

3. Diderot referred to Chardin as part of *"L'Ecole de la realité,"* in his *Salons* (1759-1781). He studied this further in his "Essais sur la peinture." Diderot felt that Chardin had captured nature itself ("Salon de 1763"). For further reference, see Diderot, *Oeuvres esthétiques,* ed. Paul Vernière (Paris: Garnier Frères, 1959).

4. McCoubrey, *Studies in French,* p. 75.

5. See Diderot, "Salon de 1763" and "Salon de 1765," in *Oeuvres esthétiques,* ed. Paul Vernière (Paris: Garnier Frères, 1959), pp. 483-86.

6. McCoubrey, *Studies in French,* p. 6. In the nineteenth century the question of size and intimacy, learned from Chardin, was of principal importance to a still-life painter.

7. McCoubrey was able to determine several types that were used frequently by still-life painters. See McCoubrey, *Studies in French,* pp. 48-56. Perhaps the most careful enumeration of different modes of early still-life representation is given by Faré, *Nature Morte,* 1:97-129. Faré clarifies the different meanings in still-life examples of the seventeenth century and presents a foundation from which examples of the eighteenth century can be studied. For the eighteenth century, see Faré, 1: 203-37.

8. Ibid., p. 9.

9. Félibien, *De l'origine de la peinture,* quoted in McCoubrey, *Studies in French,* p. 10.

10. Ibid., p. 19.

11. Félibien was the source for these ideas. His estimation of still-life painting persisted into the nineteenth century, when many still-life artists continued to paint flowers or fruits for the burgeoning decorative arts industry.

12. McCoubrey, *Studies in French,* p. 19. This deprecating attitude seems to have permeated the artistic framework of the time.

13. See McCoubrey, *Studies in French,* chapter 3, "Le Goût flamand," for an examination of some of these themes. For a slightly different enumeration of basic still-life themes, see Faré, *Nature Morte,* especially vol. 1, chapter 3, "Principaux thèmes et la Nature Morte," pp. 203-37.

This is a study of the types used in the eighteenth century. It is significant that Chardin did not paint still lifes of meals already prepared or abandoned (i.e., as did the Dutch from the seventeenth century). Instead, his sense of decorum led to the creation of scenes emphasizing the moment before the meal commenced, when a stillness pervaded the setting.

14. Rosenberg, *Chardin,* notes that from 1730 on Chardin did studies of kitchen interiors. These scenes used commonplace objects and were another variant of the dining-room still lifes for which he was best known.

15. Rosenberg, *Chardin,* pp. 74-76, lists Chardin's patrons in the eighteenth century.

16. McCoubrey, *Studies in French,* p. 93, notes that Chardin returned to still life when it was about to be superseded by history painting with moralizing overtones. For Chardin's return to still life, see Rosenberg, *Chardin,* pp. 295-336; Chardin's still lifes increased in number in his late period while his genre scenes decreased.

17. McCoubrey, *Studies in French,* p. 82.

18. Ibid., p. 91.

Observations on Contemporaries of Chardin in the Eighteenth Century

WILLIAM S. TALBOT

Comparing Chardin with his contemporaries who had earlier established or maintained the still-life tradition leads to a consideration of a painter such as Nicolas de Largillière (1656-1746), who was one of the most renowned French portraitists of the late seventeenth and early eighteenth centuries. He was also a painter of history — then regarded as the loftiest of subjects because of its demonstration of literary knowledge, discriminating choice of subject, and inventive imagery. In addition to history painting and portraiture, Largillière painted still lifes of animals, fruit, and flowers, subjects he had first executed in the coloristic Flemish manner when he was a pupil in the Antwerp studio of Antoon Goubau (1616-1698).

Partridge in a Niche [4] is among Largillière's early still lifes (1685) and represents a type of subject with a long tradition in European art. Animals and birds, often trophies of the hunt that were displayed among fruits and vegetables, appealed on several levels. Dead game depicted in such a setting with guns and hunting accessories reflected the aristocracy. Still lifes of sumptuous dining pleasures anticipated the feast itself, while the natural beauty of feathers and furs, contrasting with the shapes and textures of fruits and vegetables, provided an immediate feast for the eye.

Partridge in a Niche reveals Largillière's passion for different textures and colors. The open wing not only creates a striking outline, but displays feathers of a different color from the breast and neck. The painter has captured the softness of feathers, the hardness of the beak, the bloom and trans-lucency of grapes, the fuzzy surface of the peach, and the juicy pulp of the pomegranate. Largillière's intent was to create a precise illusion of nature's various textures and colors without visible brushwork; his finished surface is smooth.

A contemporary of Largillière, Alexandre-François Desportes (1661-1743) also painted flowers, animals, and game. He became official painter of the hunt for the court of Louis XV, sketching actual events and animals on the spot. His scenes of hunting dogs, in particular, appealed to aristocratic patrons, who were eager to acquire his pictures. Unlike many of his works, *Birds, Game, Vegetables and Fruit* (Fig. 1), which Desportes completed in 1707, is a much more modest subject. It groups together a variety of kitchen provisions in their unprepared states. Desportes effectively portrays the softness of the feathers and conveys the crispness of the leaves and stalks of vegetables.

Dutch and Flemish still-life painting was very popular in eighteenth-century Paris, and both Largillière and Desportes were aware of such pictures as Abraham van Beyeren's (1620/21-1690) *Still Life with a Silver Wine Jar and a Reflected Portrait of the Artist,* ca. 1655, which groups together costly vessels of silver, glass, and porcelain amid linen, velvet, marble, wicker, and fruits of contrasting textures and colors [1]. Objects are heaped atop each other in luxurious profusion: a bowl is tipped, an orange peel dangles, a peach-half lies open on a serving tray. The informality of the arrangement, however, is carefully calculated, and the objects are precious — not

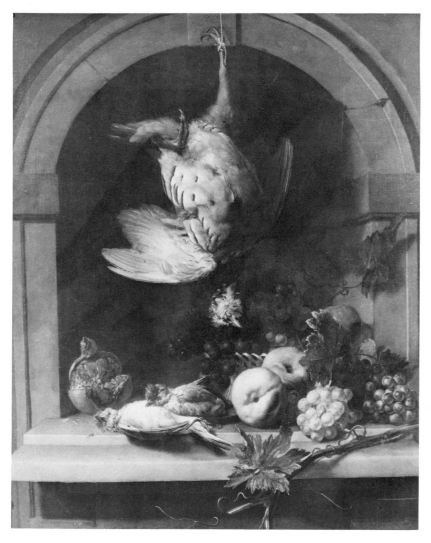

common. This is a picture of luxuries, costly furnishings, and elegant foods made to satisfy the tastes of upper-middle-class patrons, rather than to suggest everyday life.

4 Nicolas de Largillière, *Partridge in a Niche*.

Figure 1. Alexandre-François Desportes, *Birds, Game, Vegetables and Fruit* (detail).

Desportes and Largillière may also have been familiar with such pictures as Jan Davidszoon de Heem's (1606-1684) *Still Life with Lobster and Fruit*, a work that epitomizes seventeenth-century Flemish still life (Fig. 2). A quantity of colorful ob-

1 Abraham H. van Beyeren, *Still Life with a Silver Wine Jar and a Reflected Portrait of the Artist.*

Figure 2. Jan Davidszoon de Heem, *Still Life with Lobster and Fruit.*

Figure 3. Jean Siméon Chardin, *Two Rabbits with Game Bag and Powder Flask*.

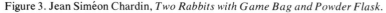

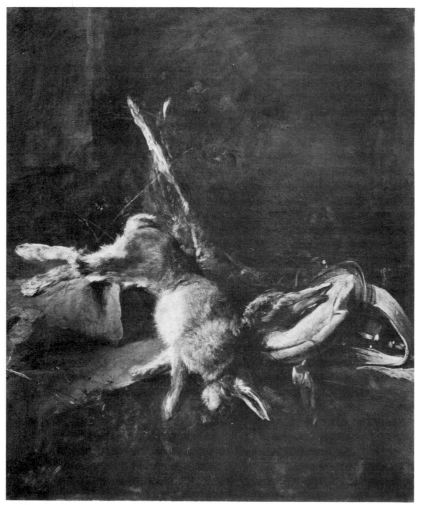

jects are displayed in what might well be described as an ingenious accomplishment in painting. Relatively small objects have been crowded together so that no one item is singled out. Transparent glass and opaque wood, whole and half-peeled fruits (smooth, translucent grapes and wrinkled, but solid oranges), a hard-shelled lobster, and delicate flowers reveal de Heem's virtuosity as a still-life painter. A bee, vital to plant life, and a butterfly, symbolic of fleeting time, provide animation, while the intrusion of an occasional caterpillar, worm, or insect intimates inevitable decay.

The still lifes of Chardin are generally less crowded and focus upon fewer objects than those of his contemporaries. In *Two Rabbits with Game Bag and Powder Flask* (Fig. 3), which he completed in the 1720s, Chardin concentrated on fewer elements, but made them more dramatic than either Largillière or Desportes.

Desportes's painting *Silver, Peaches, and Game Birds* (Fig. 4), from the late 1730s, and Chardin's *Cat Stalking a Partridge and Hare Left Near a Tureen* (Fig. 5), from the late 1720s, can be compared to point out some of the qualities that distinguish Desportes's work from Chardin's. Desportes's canvas celebrates the elegance of finely sculpted silver with its decorative plant and animal motifs. His ewer is elaborately modeled, the tureen is decorated with an intricate miniature boar's head and feet, the small pitcher recalls a seashell — the very essence of the rococo period. The flat centers of the silver trays have been angled to reflect a mound of peaches. A rich fabric covers the marble-topped cabinet, and the

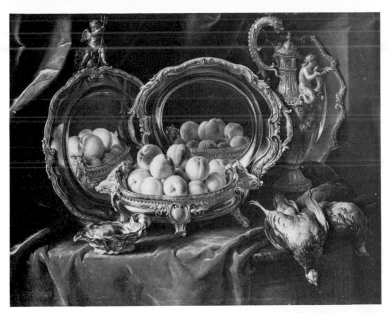

Figure 4. Alexandre-François Desportes,
Silver, Peaches, and Game Birds.

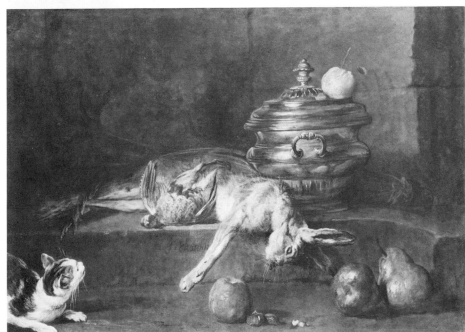

Figure 5. Jean Siméon Chardin,
*Cat Stalking a Partridge
and Hare Left Near a Tureen.*

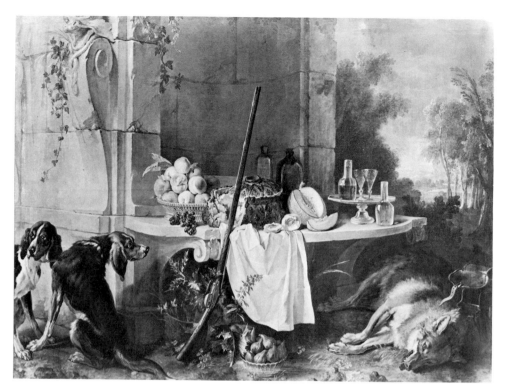

Figure 6. Jean Baptiste Oudry,
The Dead Wolf.

Instead, his tureen glows with the diffused and softened colors of all that surrounds it. Memories of apples, pears, and nuts are stimulated; reflections are recalled that are more evocative than precise renderings. Desportes's picture of silver and fruit can be measured by the precision of his images and his unusual virtuosity in depicting these objects; Chardin's images are accepted without any need to marvel at his technique.

Another contemporary who represented physical appearance with an astonishing clarity similar to Desportes was Jean Baptiste Oudry (1686-1755). Oudry was Largillière's most brilliant pupil — and Chardin's most obvious rival. Oudry's *The Dead Wolf,* 1721 (Fig. 6), is a large outdoor hunt scene that includes Oudry's specialty: expressive hunting hounds. Displayed against an architectural niche, the refreshments of crusty pâté, fruit, and wine are brightly lighted, distinct, and appetizing.

Chardin's *The Buffet,* 1728 (Fig. 7), is also a large canvas that includes a hunting dog. Chardin shows less variety and more unity than Oudry. Chardin's setting is less specific; his architecture somewhat vague. While *The Buffet* displays a bounty of food pyramided in the Flemish tradition, the shapes, colors, and relationships among these objects become more important than precise description.

game birds provide contrasting color and texture. In the Flemish tradition of de Heem, Desportes painted with astonishing clarity, convincing the viewer of an object's actual presence. He achieved a very close imitation of the appearance of silver, fruit, and feathers. The silver is a solid reflective metal that reveals the materiality of the peaches not once, but twice, in precise reflections.

Chardin's tureen is a graceful, but useful object, elegant in profile rather than in decoration and surface. Its ornamentation is not detailed but merely suggested, and its gleaming, curved surface, which catches the color of the fruit, precludes the exact reflections that Desportes achieved. Chardin was not interested in mirror images — perfect reflections of reality — and he never used flat mirrored surfaces in his paintings.

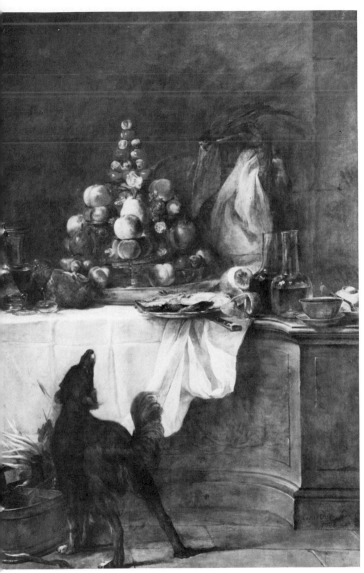

Figure 7. Jean Siméon Chardin, *The Buffet*.

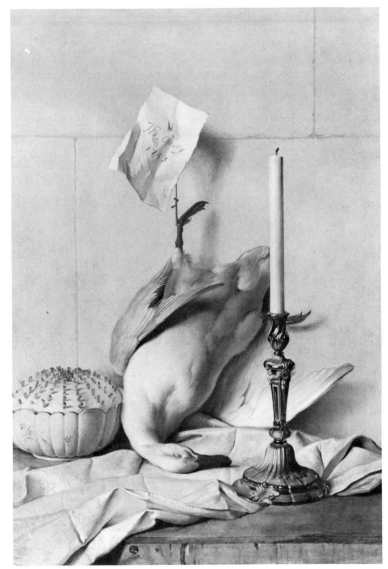

Figure 8. Jean Baptiste Oudry, *The White Duck*.

19

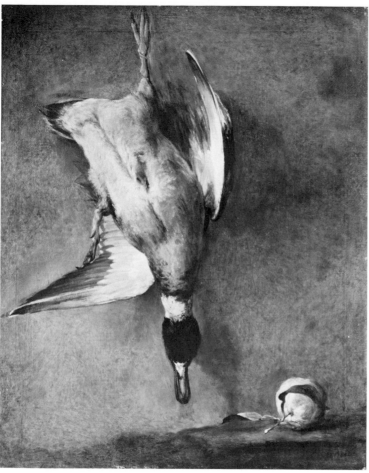

Figure 9. Jean Siméon Chardin, *A Green-Neck Duck Hung on the Wall and a Seville Orange.*

One of Oudry's most famous works is *The White Duck,* 1753 — a masterly rendition in whites (Fig. 8). It is an artistic exercise in tonal painting that reveals Oudry's distinctive virtuosity. It recalls a story from Oudry's youth, when he was still a pupil of Largillière. The master required that Oudry gather wildflowers for a lesson in still life. Oudry selected a brightly colored bunch, but Largillière made him replace it with one of only white blossoms so that he might learn the subtleties of colored shadows and half tones — a lesson in close observation that Oudry never forgot.

A Green-Neck Duck Hung on the Wall and a Seville Orange, painted between 1728 and 1730 (Fig. 9) — perhaps a study and not a finished oil — reveals Chardin's particular style. Here, the paint suggests feathers not by verisimilitude, but by color and texture. Oudry's *The White Duck* is a very specific duck hung by a knotted string from a hook in the joint of a stone wall, but Chardin's duck is depicted against a nonspecific background with less concern for the supporting cord and hook that maintain so complete an illusion of reality in the Oudry. The neck of Oudry's duck lies in a gentle curve that parallels the wing feathers; in Chardin's work, the duck hangs in a natural, seemingly unarranged fashion, breast outward. Notice, also, that Oudry's elegant candlestick, tablecloth, and porcelain bowl are placed together on a well-defined tabletop; Chardin's orange rests on a surface that merges with the background, so that the presence of the orange — its color and its texture — is emphasized.

5 Jean Baptiste Oudry,
Hare and Leg of Lamb.
See also color plate.

Oudry's way of rendering nature and composing his subjects is again evident in comparing his *Hare and Leg of Lamb*, 1742 [5], with Chardin's *Wild Rabbit with Game Bag, Powder Flask, Thrush, and Lark*, 1730 (Figs. 10, 34). Oudry painted his hare in stark silhouette against a monochrome background that emphasizes the difference between the furry pelt and glistening fat. He creates the illusion of space not by a projecting ledge or tabletop, but by the hare's shadow. The direct placement of the rabbit and meat in the forefront and the meticulous attention in the painting to each detail create an arresting illusion that is even more powerful than *trompe l'oeil*. For Chardin, a surface does not have to be opaque, translucent, or reflective, but seems to be all three. Surfaces are obliterated as simple meeting points of inner substance and surrounding air. Not constrained by exact imitation of external appearance, Chardin achieved forms far more evocative than his predecessors or contemporaries.

Oudry painted *Hare and Leg of Lamb* for the dining room of Monsieur de Vaize. It may have been intended for an overmantel to enhance the decor of the small, intimate dinners that were then becoming more fashionable than the gargantuan feasts of the preceding era of Louis XIV. His successor, Louis XV, was an epicure whose reign marked a growing appreciation for the plan-

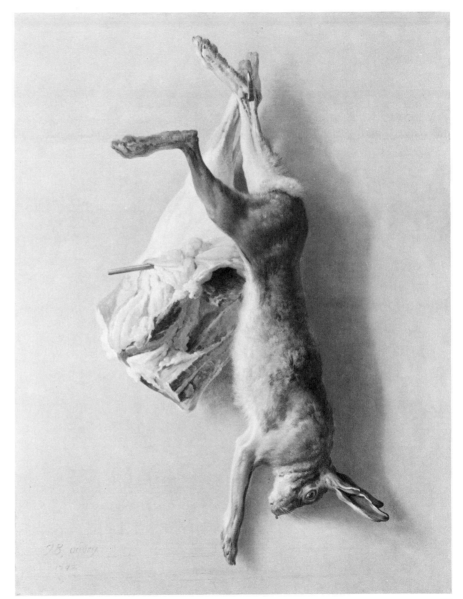

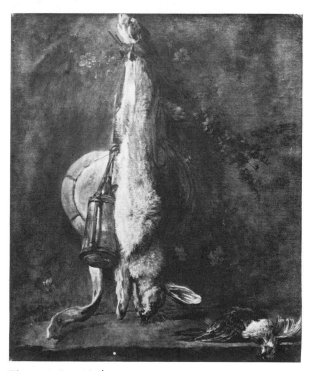

Figure 10. Jean Siméon Chardin, *Wild Rabbit with Game Bag, Powder Flask, Thrush, and Lark.*

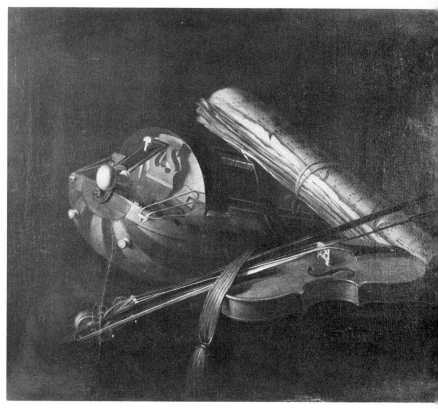

3 Nicolas-Henry Jeaurat de Bertry,
Instruments of Music.

ning, preparation, and presentation of French cuisine — which had a marked effect upon the demand for still lifes as well.

The upper-middle class, who had recently become wealthy in industry, trade, and finance, emulated the life style of the nobility. This included a concern for fine food and an appreciation for paintings that evoked the richness of the marketplace and kitchen. Still-life paintings appealed to these new patrons, who preferred images derived from nature, rather than subjects which required familiarity with history, mythology, or religion.

While Chardin's *oeuvre* is not nearly as large as Oudry's, his influence on contemporary painters and subsequent generations was very great. His works were imitated, copied, and forged. Some of these so-called imitations or works that emulate Chardin reveal what fellow artists most appreciated in his work.

One of the Chardin imitators was Nicolas-Henry Jeaurat de Bertry (1728-1796), a still-life painter with a particular fondness for musical instruments. His 1756 painting, *Instruments of Music,* shows a hurdy-gurdy, a violin, and a roll of sheet music, and it is representative of his style with its smooth, gleaming surfaces set against surrounding darkness [3]. Jeaurat de Bertry also painted common kitchen utensils, using many of the same objects Chardin had made popular, but preferring glossy, reflective surfaces and more crowded arrangements. He adopted Chardin's casual placement as well, but not the dry finish that is so apparent in Chardin's *Musical Instruments and Basket of Fruit* (Fig. 11). Nor did he em-

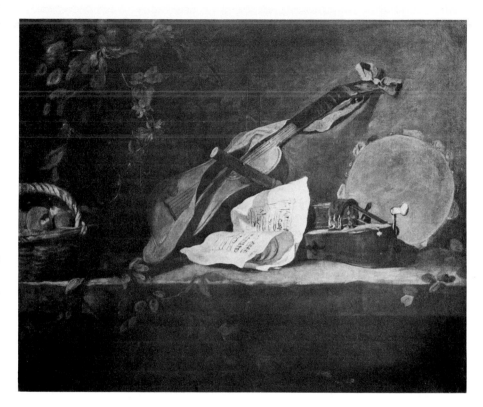

phasize the abstract forms of the objects — a characteristic of Chardin's works during the 1750s. Another still life of Chardin's with a similar music theme, *Attributes of Music* (Fig. 12), again shows Chardin's preference for merely suggesting the surfaces of instruments rather than describing them minutely.

Shortly after Chardin was granted living quarters in the Louvre in 1757 — no small indication of his reputation as an artist — Thomas-Germain-Joseph Duvivier (1735-

Figure 11. Jean Siméon Chardin, *Musical Instruments and Basket of Fruit.*

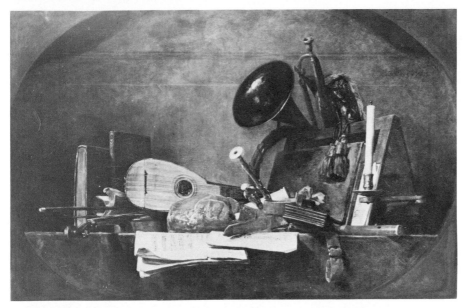

Figure 12. Jean Siméon Chardin,
Attributes of Music.

1814), the son of one of Chardin's fellow
residents, became his pupil. By 1750,
Duvivier was exhibiting and receiving criti-
cal notice for his similarity to Chardin. His
particular interest was allegory, and his
Attributes of Sculpture and Architecture [2]
— intended as an overdoor and completed
in the 1770s or 1780s — shows this resem-
blance to Chardin. The disarray of books,
papers, tools, and instruments with a plas-
ter *Leda and the Swan* is not unlike Char-
din's *Attributes of the Arts and Their Re-
wards* of 1766 with its plaster *Mercury* by
Pigalle (Fig. 13). Chardin's distinctive
treatment and definition of each object
while maintaining a harmony among shapes
and spaces, however, is quite different from
the composition in the Duvivier, where ob-
jects are less well defined and foreshortened
— interrelated by the compactness of their
arrangement rather than by form itself.

Another emulator whose work suggests
Chardin in both subject matter and pictorial
power was Henri Horace Roland de la
Porte (1725-1793). He was a pupil of Oudry
and had absorbed that master's strong incli-
nation toward illusionism (the close imita-
tion of optical appearance). His subjects

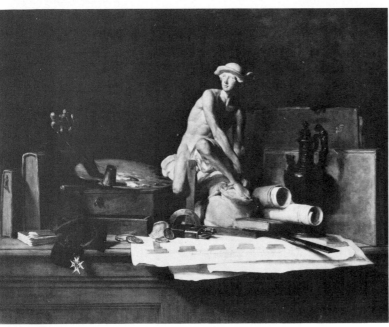

Figure 13. Jean Siméon Chardin,
Attributes of the Arts and Their Rewards.

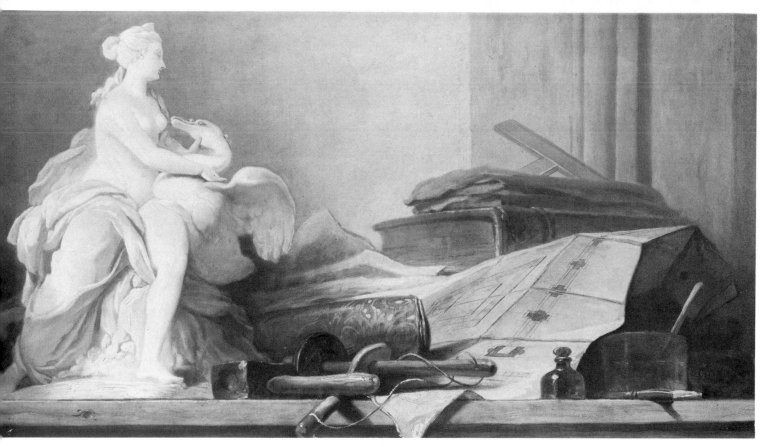

2 Thomas-German-Joseph Duvivier, *Attributes of Sculpture and Architecture*.

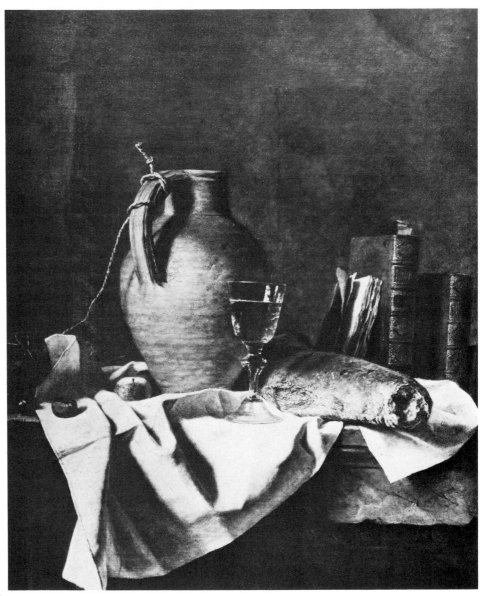

6 Henri Horace Rolande de la Porte, *Preparations for a Simple Lunch*.

were the similar everyday objects favored by Chardin, such as those seen in *Preparations for a Simple Lunch,* 1763 [**6**]. But he achieved a more dramatic presentation through stronger light and deeper shadow, as well as by the central placement of the large jug that dominates the canvas. His work can be compared with *Duck Hung by One Leg, Pâté, Bowl, and Jar of Olives* (Fig. 14), a picture that Chardin completed one year after Roland de la Porte's work, and one marked by a gentle harmony of scale, composition, and color.

The duck's position in front of the light-colored wall, the drape of the tablecloth beyond the ledge, and the projection of the black knife define a surprisingly ample spatial depth. In Roland de la Porte's work, however, it is the roundness of the large, strongly lighted jug, the heavy folds of the tablecloth, and the projecting loaf that create the illusion of space — in a stark and vigorous way. Comparison of Chardin's work with Roland de la Porte's reveals the airiness of the Chardin and his ever-subtle choice of objects according to their scale and their placement. It is significant to note that Chardin seldom painted objects of sharply different proportions. Nor did he use such devices as a highlighted string simply to add drama to his pictures.

Chardin's champion, Diderot, referred to Roland de la Porte's style as mere illusion

and easy to paint. He wrote that the imitation of Chardin's subjects without the duplication of Chardin's subtle style made Roland de la Porte "another victim of M. Chardin."[1] Despite Diderot's strong dismissal, Roland de la Porte's pictures have often been confused with Chardin's. Even *Preparations for a Simple Lunch* — with all the differences noted — was long mistakenly attributed to Chardin.[2]

Anne Vallayer-Coster (1744-1818) was one of the most accomplished eighteenth-century French painters of the domestic still life. Her range of subjects included flowers as well as kitchen groupings of meat, fish, game, and utensils amid fruits and vegetables. Such a picture as *Basket of Plums* [7], 1769, is certainly similar in subject to Chardin's *Basket of Plums with Walnuts, Currants, and Cherries* (Fig. 15), ca. 1765, but quite different in treatment. Chardin's loose, dry brush provides a texture that softens the atmosphere. Vallayer-Coster, on the other hand, painted with more vivid colors and brighter highlights. Each individual plum and piece of straw in her basket is separate and distinct. The paper wrappers of the cakes are crisp, and the highlighting along the entire length of the hanging tendril of straw is typical of her careful detail. She was probably indebted to Chardin for the simplicity, spaciousness, and repose of her picture, but her paint is less textured, the color less broken, the light less diffused.

One of Chardin's favorite subjects was the copper pot. Its dull reddish exterior, or silvery, tinned interior, glows in many of his kitchen still lifes. A copper pot is prominent

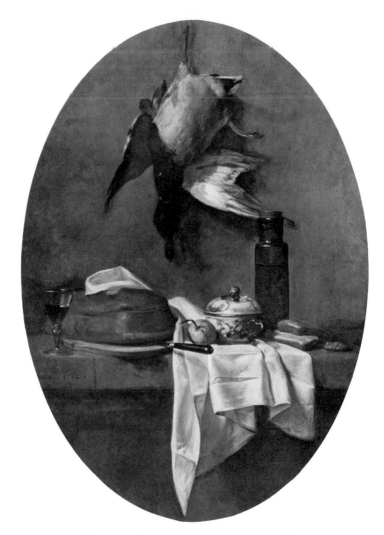

Figure 14. Jean Siméon Chardin, *Duck Hung by One Leg, Pâté, Bowl, and Jar of Olives.*

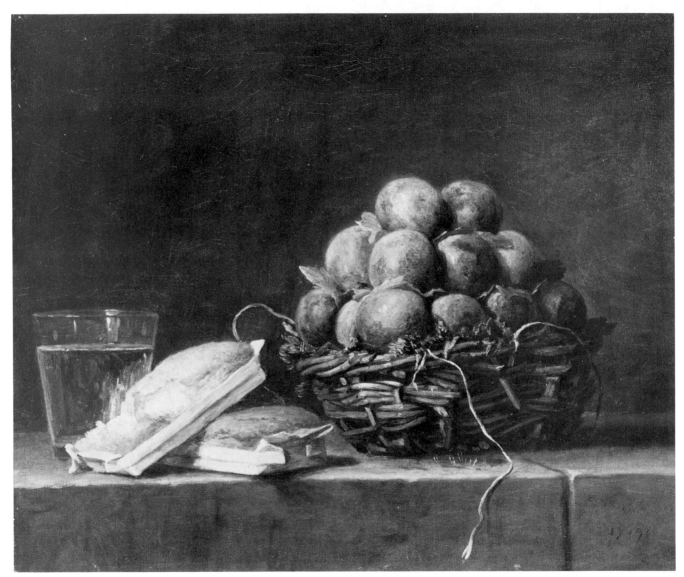

7 Anne Vallayer-Coster, *Basket of Plums*.

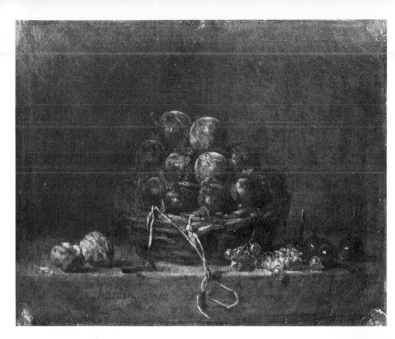

Figure 15. Jean Siméon Chardin, *Basket of Plums, with Walnuts, Currants, and Cherries.*

Figure 16. Michel-Honoré Bounieu, *Preparations for a pot-au-feu.*

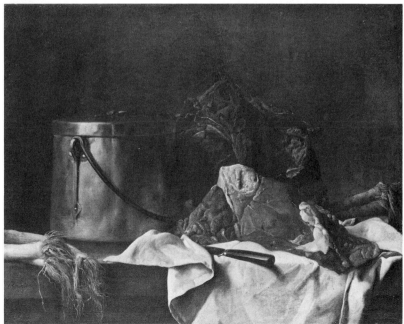

in *Preparations for a pot-au-feu* (Figs. 16, 44), which also includes root and leafy vegetables as well as a large piece of meat. This canvas has some of the simplicity, clear organization, and breadth of touch usually associated with Chardin, and it is not surprising that the picture entered the Louvre with the La Caze bequest as an original Chardin. Curatorial doubt, however, led to a status of "attributed to Chardin," and positive identification had to await the removal of some overpaint in 1956, which revealed not Chardin but the signature of Michel-Honoré

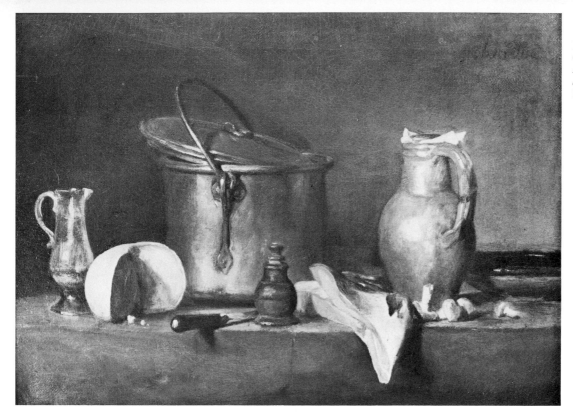

Figure 17. Jean Siméon Chardin, *Copper Pot with Oil Cruet, Cheese, Kitchen Knife, Pepper Box, Slice of Salmon, Four Mushrooms, Water Pitcher, and Bowl.*

Bounieu (1740-1814), a little known, but versatile painter of history allegory, genre, landscape, and still life.[3] Bounieu learned the lessons of Chardin well, but lacked the touch that in Chardin's *Copper Pot with Oil Cruet, Cheese, Kitchen Knife, Pepper Box, Slice of Salmon, Four Mushrooms, Water Pitcher, and Bowl* (Fig. 17) transformed the copper into a shimmering surface — and gave the glazed earthenware water jug, the glass pitcher, and the pepper box a rich and evocative artistic significance far beyond their intrinsic value.

Such artists as Largillière, Desportes, Oudry, Jeaurat de Bertry, Duvivier, Roland de la Porte, and Vallayer-Coster demonstrate that the still-life tradition in which Chardin worked was well established in the eighteenth century. It was a familiar and popular category in the Salon exhibitions and appeared frequently in the writings of critics. The style and accomplishments of Chardin are singular and eloquent statements within the context of a tradition that was to become an integral part of a later revival of still life in the nineteenth century.

1. "Salon de 1765," in Denis Diderot, *Salons,* eds. Jean Seznec and Jean Adhémar, vol. 2 (Oxford: Clarendon Press, 1960), p. 142.

2. Pierre Rosenberg, *The Age of Louis XV* (Toledo, Ohio: The Toledo Museum of Art, 1975), p. 69.

3. Hélène Adhémar, "Une nature morte de Michel-Honoré Bounieu autrefois attribuée à Chardin," *Bulletin du Laboratoire du Musée du Louvre* 1 (June 1956): 63-66.

The Revival of Still-Life Painting in the Nineteenth Century

After the neoclassic period (1785-1820) — a time when the still life continued to be regarded as the lowest level in the hierarchy of types — there was a steady decline in the number of history paintings exhibited at the Salons.[1] Progressive painters gravitated away from the esoteric themes of the classical past; they tended, instead, toward a reexamination of their environment (landscapes) and toward depicting what they observed closely (still lifes). Nonetheless, when a still-life painting was exhibited at the Salon, the traditional criticisms persisted. Some critics continued to refer to still-life painters as men without talent and to see their canvases as devoid of artistic design.[2] Despite these negative comments, the number of still-life painters continued to increase. Their works, in particular, were sought by art dealers, who found a ready market for such images among upper-middle-class clients.[3] Thus, the same conditions that had enabled Chardin to rise to a position of preeminence during the eighteenth century recurred in the early nineteenth century (i.e., 1830-1848, the period that can be referred to as the Age of Louis Philippe). Private collectors as early as the 1830s were attracted to these works not only because of their themes, but because a greater number of these impressive, original works became available. In addition, since these compositions were often small in scale, they could easily fit in town houses or apartments. The new middle-class patrons preferred scenes of actuality, and this, too, encouraged the tendency among artists to complete more realistic renderings of nature.

As the works of the new still-life painters began to appear at the Salons during the 1840s, there was a concurrent movement to reexamine previous still-life artists, who would be useful models to follow. Thus, while some ascertain the revival of interest in Chardin as taking place in 1845/46 — when Chardin's works were hung in the Louvre and when Pierre Hédouin published the first major collection of Chardin's works — this interest in Chardin was part of a much wider, more general resurgence of interest in still life that involved many painters, collectors, and critics.[4] These contributing influences that led to the revival of interest in Chardin cannot be divorced from one another. The renewal of still-life painting is a complicated movement that must be examined from many distinct viewpoints. In order to understand how these new still-life painters created, it is essential to examine how Chardin served as a model par excellence, both in his pictures and in theory. For his work and career enabled a new generation to extract those ideas and motifs that were most appropriate for their own century.

Some early nineteenth-century still-life painters, among them Philippe Rousseau (1816-1887), were able to realize their full potential in several categories.[5] Such painters based their compositions on the study of "ordinary nature" as well as on an appreciation of past masters who they believed could assist their development. As early as 1833, Gabriel Laviron (Fig. 18), in his review of the Salon, emphasized the still life as an art form with a recognizable history and denounced the general lack of sym-

Figure 18. Jean Gigoux, *Portrait of Gabriel Laviron.*

Figure 19. Philippe Rousseau, *The Black Hen.*

pathy many held for the still life.[6] Laviron's remarks, and his defense of still life, enabled younger painters to realize that those earlier painters who had rendered nature successfully (such as Caravaggio [1573-1610] or Géricault [1791-1824]) were also artists who had been able to paint still lifes.[7]

Laviron's writing had an immediate effect upon Rousseau, whose entry at the next Salon in 1834 — a Normandy landscape — revealed his study of nature, even though his still lifes from this same period (Fig. 19) showed an appreciation of past masters such as Oudry.[8] Rousseau was the first of the new generation to work in both of the "lower" types (still life and landscape), making use of "personal expression" and at the same time demonstrating a grasp of art-historical models. Rousseau's interest in earlier artists continued and he eventually acquired two major works by Chardin for his own collection.[9]

Rousseau's career is worth examining in some detail because he was often linked with Chardin by the critics and because late in life he affirmed that Chardin had been "his god."[10] Rousseau's life also exemplifies how a nineteenth-century painter reestablished the still life as a type while assisting in the revival of the name and work of Chardin. Rousseau was first attracted to one of Chardin's chief rivals, Oudry, perhaps because Oudry's il-

32

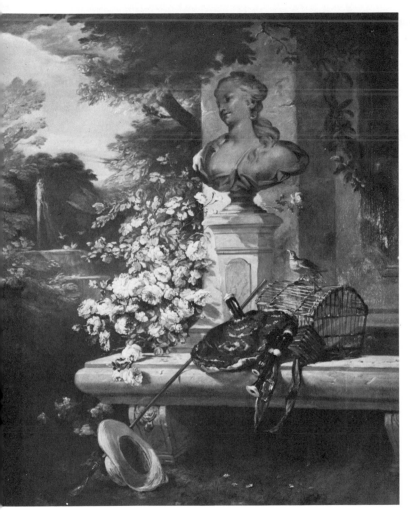

Figure 20. Philippe Rousseau, *The Garden Bench*.

Figure 21. Philippe Rousseau, *The Fountain*.

33

lusionism and technically perfect surface inspired Rousseau to create images that convey realistic detail.[11] This "realism" proved most popular with collectors and, since it was a conservative still-life trait, may have helped establish Rousseau as a well-endowed master of the still life who understood its history and its inherent qualities.

As a favorite under the Second Empire (1851-1870), Rousseau received distinction as a decorator utilizing still-life motifs (Figs. 20, 21).[12] To the standard interest in flowers and animals, however, Rousseau added literary associations (such as bagpipes or the birdcage) to create a type of image in which unusual objects recalled the pleasures of the eighteenth century — but in a conventional way — without altering the form and composition that were changing the direction of still life during Rousseau's own lifetime.

Because he was a deft practitioner in several revival styles and because he was skilled in all the categories of still life, Rousseau thus characterizes important features of the still-life revival that are too often overlooked.[13] It must be clearly understood that these artists of the still-life revival were not dependent upon one master. Since there were many styles current in this period, the eclectic tastes of the various patrons (especially those from the court of Napoleon III) often dictated changes in taste and theme. At his death, despite many works that show little influence from known examples by Chardin, even Rousseau's obituary proclaimed: "French art has just lost its modern Chardin."[14] This curious

tribute is found in accounts of other still-life painters of the time, but it is important to understand that the obsession with Chardin was only one part of a general fascination with past masters that typified the period.

The judgment that a work by Rousseau bears a resemblance to the way in which Chardin composed his canvases — with a feeling for studying shapes on an intimate scale such as that shown in [26] — must be tempered by an acknowledgement, also, that critics were often comparing the general efforts of a given still-life painter (such as Rousseau) with the merits of a past master. By comparing Rousseau with Chardin, writers were placing Rousseau in the preferred historical context just as they were noting that many of his works — from their viewpoint — rivaled the quality of Chardin's finest achievements. To assume from this that Rousseau studied only Chardin, however, is presumptuous — despite the fact that his finest work was undoubtedly influenced by the way in which Chardin had composed and painted.[15]

The dominance of Chardin over the whole still-life movement served as more than a means of comparison during the nineteenth century. It also provided a theoretical pinnacle that still-life painters strove to achieve in their own work. Further, Chardin epitomized a French master who fully satisfied the nationalistic requirements that were so important in the nineteenth century: Chardin was the one model to be equaled if a painter was to achieve and record his own personal sensations in the creation of a still life.

The Chardin Revival

CRITICS

The rediscovery of Chardin as a significant painter — one who had a message for nineteenth-century artists — came about slowly. During the period from 1780 until 1846, Chardin received little notice. Many of his paintings disappeared once the patrons who had acquired his work died.[16] The oblivion into which his name fell was hastened by the nature of the type of art in which he specialized. As noted earlier, still life was looked upon with disdain by serious members of the French Academy. History paintings, works with a morally uplifting social message, were the type of canvases increasingly exhibited at the Salons.[17] Those few writers and critics who mentioned Chardin at all were often misinformed, even about the date of his birth.[18] Some were just as ignorant of Chardin's fame during his own lifetime. If Chardin were mentioned at all during this period, it was his ability to render familiar objects which drew praise.

But by the 1820s, still-life and genre painting (realistic subjects or scenes from everyday life) began to reemerge as appropriate ways of painting. The rediscovery of Chardin was part of this development. By 1845 Chardin was singled out by curators at the Louvre as an artist of great importance, since he could be identified as both a "defective rococo painter" and a forerunner of Realism.[19] The trend toward Realism in this period prior to the 1848 Revolution was also supported by leading members of the

Louvre, among them Philippe Auguste Jeanron (a Realist painter himself, as well as an advocate of other Realists). The most important event of the 1840s to influence the art world and affect the development of the still life was the publication of two articles by Pierre Hédouin in *Bulletin des Arts,* November and December, 1846, and especially the catalog of Chardin's works that appeared in the December issue.[20]

At the same time, other critics began to compare Chardin's significance with individual contemporary nineteenth-century French artists. For example, when Champfleury reviewed the works of François Bonvin (1817-1887), he described Bonvin as a painter in search of his own Diderot.[21] Indeed, at the 1849 Salon, Champfleury recognized the still-life arrangement within Bonvin's *Cook* as an echo of Chardin's ability to treat still life compassionately and objectively. Other well-known critics also acknowledged the excellence of Chardin, among them Charles Blanc and Théophile Thoré. Thoré, a fervent supporter of Realism who encouraged artists to paint what they saw,[22] called for the revival of serious masters of the past and urged the Louvre to reorganize its own disorderly collections, purchase works from others, and exhibit the collected works of specific masters. It may have been due to Thoré's prodding that the Louvre obtained several Chardins (perhaps three) by 1852 and then gradually acquired many more from such collectors as Laperlier (1867) and La Caze (1869).

Critical writings after the 1850s culminated in a publication on Chardin prepared

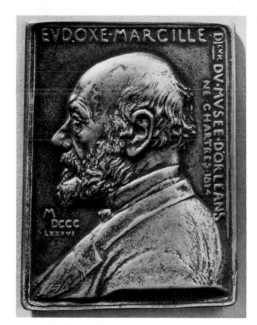

Figure 22. Oscar Roty, *Medal of Eudoxe Marcille.*

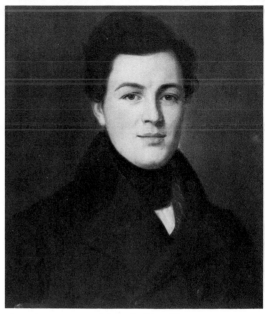

Figure 23. *Portrait of Camille Marcille.*

by Edmond and Jules de Goncourt that appeared in *Gazette des Beaux-Arts* in 1863. This work did much to familiarize a wider audience with Chardin's achievements and prepared the way for the internationalization of his name in the last quarter of the nineteenth century and on into the twentieth.[23]

COLLECTORS

During the period in which the early critics were rediscovering Chardin, several perspicacious collectors hunted out his work among secondhand dealers and small Parisian shops. Many of the Chardins that François Marcille (1790-1856) acquired for only a few francs formed the basis of a large collection which existed prior to 1856. The Marcille collection — which was, in part, inherited by his sons Eudoxe (Fig. 22) and Camille (Fig. 23) — might well be considered one of the largest Chardin collections

of all time.[24] That Camille (a painter) and Eudoxe were both involved in the arts suggests how deeply this family was committed to the Chardin revival and all its ramifications.[25]

Two other collections of the period are worth noting, since their owners were well established and because they made their acquisitions and their galleries available to painters eager to study Chardin in a perfect environment. The first was organized by Laurent Laperlier (1805-1878) and included at least twenty-five Chardins, some of which were sold in 1867 when Laperlier left France for Algiers.[26] Laperlier was not only an enthusiastic collector of past masters but an active supporter of contemporary painting. He owned a number of works by François Bonvin, a Realist painter who also guided Laperlier in his acquisition of Chardin originals.[27] While it is not certain when the majority of Laperlier's collection was accumulated, a letter from Bonvin to Laperlier dated 8 February 1851 demonstrates the interaction between collector and artist in a search for genuine Chardins.

I have hastened to see the two Chardins. . . . The first one, La Pourvoyeuse, is beautiful, very beautiful, and of a good type, in spite of the clumsy retouchings done to the figure, to the right arm, a little to the apron and to the purple stocking.

The second, which must have been a Chardin, is not one any longer, as far as I am concerned. This painting must have been entirely repainted by a pretentious imbecile who has completely covered up the master. The top of the table, the playing cards, the clothes of the older boy were poorly retouched and smeared; the shoes, the heads of the two children reddish brown and stupidly reworked. All that, I assure you, is not by Chardin or is no longer by Chardin.

The Pourvoyeuse is something that I find worthy of your desire and worthy of Chardin. As for the other — which must have been a masterpiece — in spite of its precision, its harmony and its brilliant color, I dare say, dear Sir, do not take it; you would mar your collection.[28]

Significantly, Laperlier accepted Bonvin's innate sense of good taste and avoided purchasing a work which had been entirely overpainted and which Bonvin felt would ruin the collection he was trying to formulate.

The history of Bonvin's relationship with Laperlier, chronicled in a letter written 7 June 1878, shows an admiration for Chardin as well as an appreciation for still-another neglected eighteenth-century artist, Greuze.[29] Bonvin writes:

During Chardin's reign, [my relationship with Laperlier], though very interesting and extremely useful to my studies, was often strained to the point of breaking on account of other painters which the secondhand dealers persuaded Laperlier to buy. They deceived him by selling him works by Chardin, which most of the time were not even by Jeaurat!

After each new acquisition, I received a letter asking me to come and see, at the military supply store of Bercy, the new masterpiece, which I would then condemn inexorably to the rubbish pile after studying it and discussing it. The dealers were taking a definite dislike to me, and if Mr. Marcille, the father, hadn't come to my rescue, it would have been the end of my reputation to assess paintings. He was not the only one, moreover, to be taken in. Delacroix, Ingres, Charles Blanc, even that good Mr. La Caze shared his delusions.

Delacroix had two overdoors — two canvases of six — fruit and grapes which were not, in fact, by Chardin. Old Ingres pulled his hair out for having missed an overdoor which I had bought for 40 francs to surprise Mr. Laperlier. This overdoor, The Arts, was very important, to be sure. It was signed Chardin filius, and this poor Mr. Ingres, who had not read Diderot, maintained that since Chardin had no son, this painting was by the father. It should be noted, however, that the style and color were unlike the style and the color of the father!

One day, I received a request from Mr. Laperlier to go, as fast as possible, to Ch. Blanc, rue Laffitte, to inspect a canvas by Chardin representing a child lying down near an overturned basket of grapes. The child was munching on a slice of bread, his shirt rolled up over his stomach, while he voided like a fountain. I answered, by return post, that I didn't have to see the thing to declare that it could not be by the master, since no such subject could have been painted without a model and that Chardin couldn't have done it. . . .

Every time I went to Mr. La Caze (almost every Sunday during the winter), we held a discussion before the charming portrait of the French school Woman with a Book, whose frame carried the name of Chardin. The same happened for the canvas showing a pitcher, some chestnuts, a loaf of bread, and a napkin, which Mr. La Caze had also baptized with the same signature — as if Chardin could have tolerated a fine napkin in such a rustic composition! . . . He would tell me: "You are making me un-

happy when you change the name of my children." I would answer: "You will only have more merit for having adopted such charming unknowns!" Finally, he changed the mistaken attribution!

It wasn't an easy task, therefore, to educate an amateur as decisive as Mr. Laperlier. I found only one way, which was to convince the kind and obliging Mr. Marcille to agree to lend us his Chardins one at a time. First, it was the *Draftsman,* then the *Scourer,* and finally the *Tavern Keeper,* which Mr. Laperlier had lithographed, at his own expense, by Soulange-Tessier who had a nerveless style and who was the most incompetent of all lithographers!

My method worked admirably and, from that time on, the revelation was complete. Mr. Laperlier became more knowledgeable than all the other amateurs, and he proved it with first-rate acquisitions of overdoors. . . .

I also urged him toward the Spanish school, to strengthen his knowledge of a powerful and solid style of painting, but he became intimate with Müller, then with his student Carraud, who signed so badly and so crudely, then finally with . . . Lazerges. . . . This kind of eclecticism bored me, and little by little our relationship ended.[30]

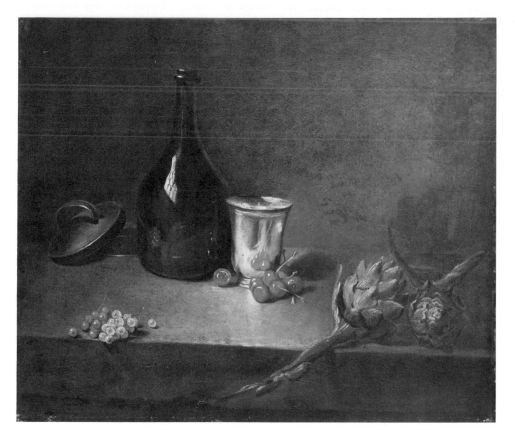

No doubt the close interaction between collectors and Bonvin benefited both parties, and helped to confirm the authenticity of many true Chardins. It is interesting that these new patrons of Chardin associated and cooperated with one another. Marcille's ready response to Bonvin's request to show his Chardins to Laperlier demonstrates a further — and unusual — rapport.

Bonvin, whom they respected both as an artist and an expert, also seems to have stimulated the search for genuine Chardins and to have educated various collectors to distinguish the master (see [**33**]).

One of the most important collections gathered together in the middle of the nineteenth century was that of Louis La Caze (a physican and amateur painter as

33 Anonymous,
Still Life with Artichokes.

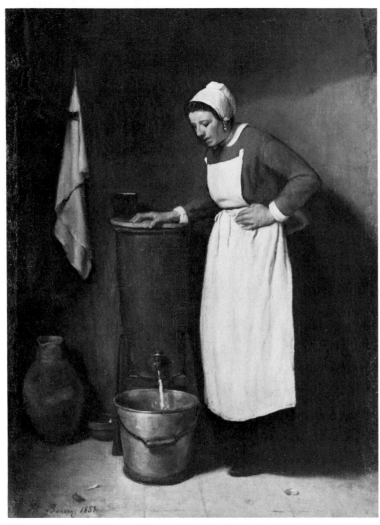

Figure 24. François Bonvin, *Woman Drawing Water*.

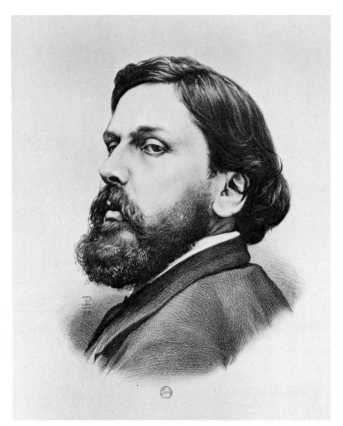

Figure 25. *Lithograph of Philippe Burty*.

well). La Caze acquired as many as eleven Chardins (in addition to canvases by Oudry), which he donated to the Louvre at his death in 1869.[31] Little is known about how La Caze obtained these works, although he, too, was assisted by contemporary painters such as Bonvin. Bonvin often visited La Caze during the winter months

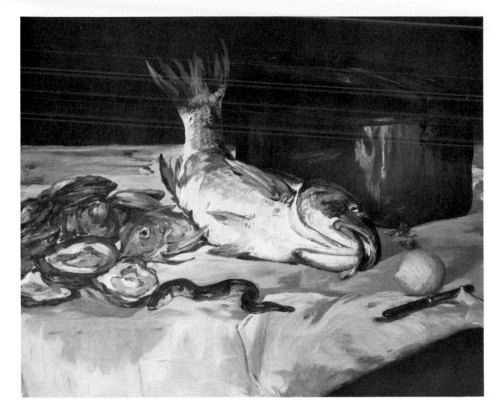

Figure 26. Edouard Manet,
Still Life with Carp.

and had access to La Caze's collection long before it was donated to the Louvre. Chardin's *The Water Urn* obviously influenced Bonvin in his own interior scene and is among several works from the La Caze collection that affected Bonvin's painting style (Fig. 24).

The collections formed by Marcille, Laperlier, and La Caze were also influential in another way. Admittedly, certain artists and critics had access to these private collections on their own, but prior to 1860 there had been no general exhibition dedicated to past French masters of the eighteenth century — least of all, to Chardin. Then, at the Martinet Gallery, the art critic Philippe Burty (Fig. 25) (1830-1890) organized a historic exhibition (1860) in which over forty canvases by Chardin were shown to the public. These works came from the three major collections of the time and marked the culmination of the private acquisitions of Chardin in the nineteenth century.[32] Many came to see this exhibition, including such artists as Edouard Manet, who was then beginning to develop his own interest in still-life painting (Fig. 26). A convincing review by Théophile Thoré about Chardin and the exhibition also contributed to this widespread new interest.

Thus, by the middle of the Second Empire, and partly as a result of the intense nationalism of that period, still life had been reestablished as a painting category and strengthened by a cult of admiration for Chardin. Chardin was seen as an important example of the French heritage and a brilliant prototype for Realist painters.

39

REALIST PAINTERS

The nineteenth-century artists who reacted to Chardin were either those painters who were intimately connected with the evolution of Realism or who had, at one time, completed Realist works. Chardin, therefore, along with certain Dutch (e.g., de Hooch, Teniers, Vermeer) and Spanish (e.g., Velásquez, Ribera) painters of the seventeenth century, reinforced the Realists' fundamental predilection for painting directly from nature, or, in other words, what they truly observed. Those who were active in painting "serious" still lifes showed an equal interest in other themes, especially humble, everyday scenes, for democracy was recognized in art also, and the need to paint what was meaningful to the artist became more important than any specific hierarchy of preestablished categories. If a painter was to reach his potential, it was essential that he not remain a specialist confined to one area. All types of art were equally important, all categories were indivisible — a democratic philosophy which governed much of the thinking of the early Realists.

Throughout the 1850s, still-life painting (of all types) continued to increase as artists sent their works to the Salons as well as to art dealers. Not all of these still-life painters were Realists. Some tried their hand at still life because they sensed a ready market based on the eclectic interests of the patrons of the Second Empire,[33] which resulted in the indiscriminate purchase of works that were genuinely innovative as well as many that were simply bastardized renditions of past styles and themes. The more significant still-life painters, however, remain those who challenged the hierarchy of Salon styles by painting simple, familiar objects reminiscent of Chardin, such as fruit, onions, asparagus, or carrots.

Nevertheless, to see all still life as a threat to the established order of superiority at the Salons, as the critic Charles Blanc interpreted it at the time, was to misread the situation and to present an intensely official attitude.[34] It was only certain types of still life, and the ways in which these examples were painted, which signaled a change for future generations. Those critics and judges who banished still life — as a whole — to the Salon des Refusés (1863) could not accept a truly Realist way of handling still life.[35] They found it simpler to castigate everyone who refused to paint rare and special objects than to recognize the formalistic changes that were being developed by painters such as François Bonvin and Antoine Vollon.

The year 1863 is considered by many as an important date in the evolution of still life since some of the examples exhibited were more respectable, and hence more appropriate for the drawing rooms of the middle class. At the same time, among the still lifes rejected at the Salon were numerous studies of cabbages, oysters, eggs, and onions, demonstrating that the number of "familiar objects" being painted was increasing so rapidly that fear was even expressed that still-life artists were "multiplying like rodents" and might eventually undermine the entire academic system.[36]

A number of conservative still-life painters (e.g., Fantin-Latour) painted in a manner suggestive of the selective approach a photographer would use in organizing his shapes, while also examining forms in a manner sensitive to light and shade. Those who practiced this type of still-life arrangement often used established themes — flowers or fruit — rather than risk less traditional inclinations.

On the other side were a number of painters whose works reflected a study of actuality, the creation of an austere atmosphere, and a study of simpler objects that had seldom been treated in such profusion. New critics, among them Jules Antoine Castagnary, supported the painting of modest subjects such as eggs and cheese and criticized painters when they ventured into formularizing their styles or became overtly Romantic.[37]

An important aspect of still-life painting was also isolated by some critics who believed that the still life should be treated on a small scale.[38] They may have believed that humble objects — essentially those with connotations of the poor — should not be painted on a scale larger than life. A larger scale might create a false impression, which would ruin the realism they were trying to depict. At the same time, Castagnary and others may have thought that by working in small dimensions the Realists could reveal their most intimate responses directly, thereby creating very personal still lifes. The new still life thus evidenced a formalistic aesthetic, since critics and painters alike were seeking the intimacy and purity that they found in the examples of

Chardin. "Indeed the role of the Realists in directing the public to still life of better quality was as important as their general toleration of the genre."[39]

THE NEW CHARDINS

Instrumental in furthering the development of still life were four painters who were variously noted in the nineteenth century as sharing certain affinities with Chardin. François Bonvin, Philippe Rousseau, Antoine Vollon, and Théodule Ribot were either compared with Chardin, or recognized as nineteenth-century reincarnations of the earlier master by critics who reviewed their works at the Salons or who wrote articles on their careers.[40] In general, however, the nineteenth century seems not to have found an equal to Chardin in still-life painting, despite the fact that critics and collectors were continually searching for his replacement. Nonetheless, critics were still eager to signal that they had found the "new Chardin," because they wanted to win for themselves the glory of having discovered a new still-life painter of comparable significance. Despite this search and the constant heralding of new still-life painters as the incarnation of Chardin, it is important to understand that the designation was a compliment — and never intended to imply that these painters were merely imitators.[41] It was a measure of respect reserved by critics for painters seeking to equal the quality of Chardin's finest imagery.

As already noted, François Bonvin was among the first nineteenth-century painters

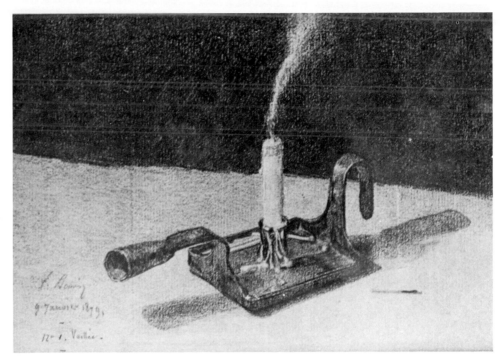

Figure 27. François Bonvin, *Still Life with Candlestick.*

to diligently locate Chardin's works so that he could study them firsthand. An active proponent of Realism, Bonvin combined an interest in genre scenes drawn from everyday life with a study of past masters who functioned as his models and guides.[42] Chardin was one of several artists Bonvin admired since his taste moved from the Dutch masters of the seventeenth century to an avid interest in the paintings of the Le Nain family — painters also being revived at mid-century as part of the search for the lost French heritage.[43]

Bonvin found his inspiration in many locations: in the private collections of his friends, such as Marcille and Laperlier; in the Louvre where he copied the works of Rembrandt and learned from the canvases of Pieter de Hooch.[44] Encouraged by the writings of Champfleury, who called for an artist to paint what he saw and his own environment, as well as Théophile Thoré who urged the painter to visit Holland in search of an art for man, Bonvin did innumerable still lifes of familiar objects. These he occasionally exhibited at the Salons, although

the majority of his works were probably shown by art dealers and found their way into private collections.

Bonvin's best still lifes were those that reflected an intimate study of small objects from his own studio. He often did drawings of these works (Fig. 27), creating humble images that can even be considered complete works in themselves. When he was called upon to work on specific commissions, such as a gift for the photographer Nadar who was his friend, Bonvin relied upon his intense familiarity with Chardin.[45] He created works that thematically suggest his interest in former masters even though his formal arrangement is more austere.

Philippe Rousseau, among the eldest of the still-life painters influenced by Chardin, was also praised by Thoré as a follower of Chardin.[46] He turned to still life after exhibiting numerous landscapes at the Salon and was highly proficient in creating different types of still life. Rousseau's fame reached a peak during the 1860s with some of his kitchen scenes that recall works by Chardin; later, he even completed an allegorical, but less successful, study of *Chardin and His Models*.[47] At his best, Rousseau understood the formalistic tendencies of his time [26], although he often wasted his talents catering to eclectic fancies.

During the 1860s, Antoine Vollon received official support when Count Nieuwerkerke, Minister of the Beaux-Arts, allowed him to copy a Ribera. In 1865 the state purchased his *Kitchen Interior,* thus assuring him success and governmental support during the Second Empire. These early works by Vollon reveal an awareness of a variety of sources, from the Dutch painters of the seventeenth century to the works of Chardin. Indeed, the pure still lifes (those without human beings or monkeys) that he completed in a less controlled impasto [31] suggest a debt to Chardin and a technique similar to that the master himself had occasionally used.

While Vollon used many themes, including landscapes and urban scenes, his still lifes with dead game [30] or earthenware objects earned for him the epithet of "the Chardin of the nineteenth century."[48] Even in his later still lifes that were influenced by the freer technique of the Impressionists, Vollon's interest in working from what he saw before him and in arranging simple, everyday objects suggest his indebtedness to Chardin. The vigor of his paint surface with its loose, bold strokes, and his preference for large scale, however, occasionally drew cries of his being a Romantic — traits which Vollon continued to practice despite his strong ties to the Realist aesthetic.[49]

Of the four painters who were most involved with the development of still life, Théodule Ribot was the least directly inspired by Chardin. His simple, natural studies of earthenware objects or peasant meals suggest an examination of Spanish sources (e.g., Velásquez), models that served as inspiration for many of his genre pieces. While Ribot's sense of formalistic arrangement and austerity recall Chardin, these same so-called Chardinesque qualities can be found in other sources that this Realist used, thereby underscoring the complexity of the still-life revival.[50]

In addition to these four painters, there were other Realists whose still lifes were suggestive of Chardin. As early as 1847 or 1849, Adolphe-Félix Cals had completed still lifes on a small scale whose intimacy and study of humble objects were comparable with Chardin.[51] A later work of his, dated 1858, maintains this influence, showing a cabbage and a dead fowl observed directly from nature, with an attention to atmosphere and texture that Chardin might have chosen [15].

Even Alexandre-Gabriel Decamps, basically a Romantic artist, is credited with helping to renew interest in Chardin.[52] In the few still lifes Decamps completed, the simplicity of his arrangement and the spareness of his setting recall the way in which Chardin composed his work. One other member of the early Realist circle, Armand Gautier, also turned to Chardin for inspiration. The direct lighting and the observation of forms on the bare shelf in Gautier's 1857 still life with book and glasses (Fig. 28) suggest a process of simplification that he must have acquired from a study of Chardin.

By the mid-1860s, Realists such as Bonvin, Vollon, and Ribot were openly criticized by Emile Zola, the writer and social reformer — and a staunch supporter of the painter Edouard Manet. Zola believed that the direction of the still life that then prevailed was false, partly because the Realists preferred common themes, but also because they were attracted to the frankness and vigor advocated by their leader Gustave Courbet.[53] Zola misunderstood the Realists' ability to simplify forms and failed to see their solid compositional arrange-

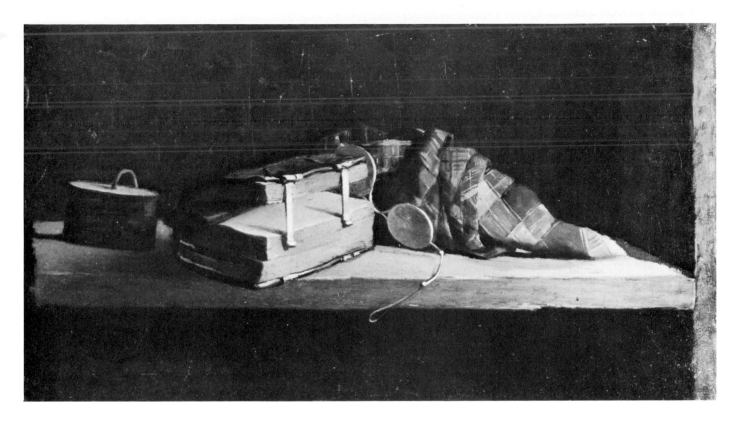

ments as a significant first step in the development of modernism. While Zola's disdain for artificial lighting and contrived organization may have been justified (for example, in some works by Vollon and Ribot where studio effects outweighed natural effects), he was overzealous in his dismissal of their attempts at pure painting. Without the direction initiated by these Realists, the pictorial innovations of Manet and Cézanne might never have been realized.

Manet's still lifes of the 1860s won immediate praise from old-line Realist sympathizers such as Thoré, and from the public as well.[54] Perhaps the freedom denied genre painters in the treatment of figures was reserved for those who painted still lifes, for formal innovations in color and shape can be detected in the works of other painters such as Vollon and Bonvin. Manet, however, copied little directly from Chardin, making his still lifes (Fig. 26) purer

Figure 28. Armand Gautier,
Still Life with Books and Glasses.

43

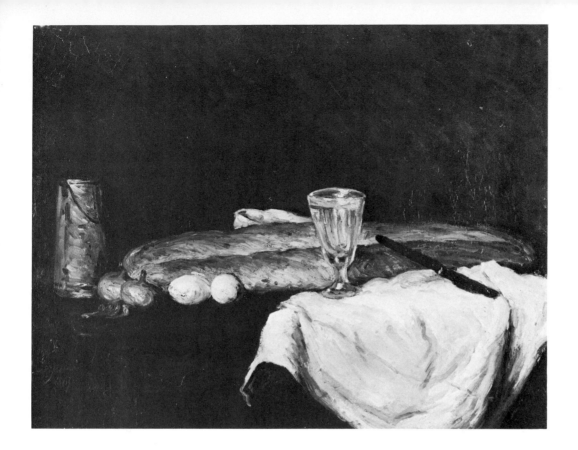

Figure 29. Paul Cézanne,
Still Life with Bread and Eggs.
See also title page.

studies of shapes than those of the immediate circle of the Realists. Manet had witnessed the possibilities within still life when he exhibited with Bonvin and Ribot at the Martinet Gallery (1865), and he continued to experiment with form and color relationships in his own still lifes, moving far beyond his contemporaries.

Aside from Manet, only Cézanne and, to a lesser degree, Eugène Boudin [14] were able to grasp the sense of structure inherent in Chardin's compositions. Cézanne's debt to Chardin is most complex, involving his reinterpretation of Chardin's compositions as studies of cylinders and spheres. Nevertheless, it is interesting to examine a Realist still life Cézanne completed early in his career (Fig. 29), which in its spareness of arranged forms, its use of a white tablecloth, and its direct manner of thickly textured paint application suggests an awareness of the Chardin revival. While Cézanne

adopted the Realist tendency for familiar objects — here, a simple meal with bread — his treatment of the forms in space and his oblique balance indicate a beginning search for underlying geometric structures that would ultimately be realized in his later complex still lifes.

Thus, the direction initiated by the Realists in their reordering of space and in simplifying their imagery was maintained well into the later decades of the nineteenth century. Since the direction was to examine compositional arrangements formally, the tendency to see still life from a thematic viewpoint was ignored. Only a few artists were able to move beyond depicting the object itself to a study of pure form.

1. John W. McCoubrey, *Studies in French Still-Life Painting, Theory and Criticism: 1660-1860* (Ph.D. diss., New York University, March 1958; Ann Arbor, Mich.: University Microfilms, MIC58-7755), p. 170.

2. Ibid., p. 111. Such critics as Edmond About and Paul Mantz continued to disparage still life during the 1850s and 1860s.

3. Ibid., p. 113. McCoubrey credits the bourgeoisie with stimulating the production of still-life canvases. This might not be the only reason, since art dealers were largely responsible for fostering the taste for the revival of still life in France. Such men as Louis Martinet, Durand-Ruel, Hector Brame, and, later, Gustave Tempelaere (all art dealers) sponsored the fashion for still life.

4. The preference for previous masters of still life can be detected in the work of Bonvin, a principal member of the still-life revival. For further information on Bonvin's revivalism, see Gabriel P. Weisberg, "François Bonvin and an Interest in Several Painters of the Seventeenth and Eighteenth Centuries," *Gazette des Beaux-Arts* 76 (1970): 359-65.

5. Almost all of the still-life painters were also active in other areas, such as genre scenes or portraits. Philippe Rousseau began his career as a landscape before turning to still life. For further reference see "Les Artistes Contemporains: Philippe Rousseau et François Bonvin," *Gazette des Beaux-Arts* I (1888): 132-39.

6. See Gabriel Laviron and B. Galbacio, *Le Salon de 1833* (Paris, 1883), pp. 367-74.

7. McCoubrey, *Studies in French,* pp. 128-29, and "The Revival of Chardin in French Still-Life Painting, 1850-1870," *Art Bulletin* XLVI (March 1964): 42.

8. For reference to this painting see *Ville de Louviers Musée,* exh. cat. (Louviers: Louviers Musée, 1929), p. 19, in which the work is noted as no. 68, *La Poule noire.* The painting was purchased by the city in 1881. Examination of the painting revealed that the date could be 1836. If 1836 is correct, it would be among the earliest known works by this artist and prior to his first known Salon still life in 1844.

9. For reference to Philippe Rousseau as a collector of Chardin, see Pierre Rosenberg, *Chardin,* exh. cat. (Paris: Editions de la Réunion des Musées Nationaux, 1979), p. 78, and cat. nos. 13 and 39.

10. See Paul Eudel, *L'Hôtel Drouot et la Curiosité en 1887-1888* (Paris, 1889).

11. McCoubrey, *Studies in French,* p. 122, comments on the prevalence of photographic realism in the works of some still-life painters in the nineteenth century. This tendency in some of Rousseau's work may have been due to his growing interest in photography. Curiously, by 1856 as part of an official commission, Rousseau was considering how photography could interact with painting. See *Bulletin de la Société Française de Photographie* (Paris, 1856), pp. 325-28. Other members of this commission included Eugène Delacroix and Théophile Gautier.

12. Rousseau was regarded as one of the better known painters in the Second Empire. See *The Second Empire: Art in France under Napoleon III,* exh. cat. (Philadelphia: Philadelphia Museum of Art, 1978), pp. 350-51. Rousseau was recognized for his "decorative skills," which led to commissions to do murals and panels for Baron J. de Rothschild and Princess Mathilde.

13. Rousseau is one of the most difficult of the still-life painters to categorize because he learned from several past traditions: Dutch, Flemish, and French. He should be the study of intensive research since he occupies an important place in the formulation of the still-life revival. Because only a few of his works have been located, it is difficult to assess the varied ramifications of his style.

14. "Nécrologie," *Courrier de l'Art,* 1887, p. 392.

15. McCoubrey, "Revival of Chardin," p. 51. Rousseau is known to have spent long hours studying Chardin's work in the Louvre, especially the eighteenth-century master's *Buffet.*

16. For reference to the major collectors of Chardin in the eighteenth and nineteenth centuries, see Rosenberg, *Chardin,* pp. 74-78. It remains difficult to trace all the works that were once privately owned, but Rosenberg has constructed a convincing provenance for many examples.

17. For a discussion of the range of paintings completed, see Hugh Honour, *Neo-Classicism* (Harmondsworth, Middlesex, England: Penguin Books, 1968).

18. Rosenberg, *Chardin,* pp. 83-84, and McCoubrey, *Studies in French,* pp. 86-87.

19. McCoubrey, *Studies in French,* p. 82.

20. See Pierre Hédouin, "Chardin," *Bulletin de l'Alliance des Arts,* 10 November and 10 December 1846. These essays also appeared in book form in 1856.

21. *La Silhouette,* 22 July 1849; in an article signed "Bixiou" and known to have been written by Champfleury, the critic stated: "*François Bonvin, peintre de la famille, il mérite un Diderot enthusiaste. . . .*"

22. For further discussion, see Frances Suzman Jowell, *Thoré-Bürger and the Art of the Past*

(Ph.D. diss., Harvard University, 1976; New York: Garland Publishers, 1977). An examination of Thoré's Salon reviews from the 1840s indicates his interest in new tendencies. See also *Salons de T. Thoré: 1844-48, avec une préface par W. Bürger* (Paris, 1868).

23. For further information see Edmond and Jules de Goncourt, *L'Art du Dix-Huitième Siècle* (Paris, 1883). This work popularized the significance of Chardin.

24. For further reference see H. de Chenevières, ''Silhouettes de collecteurs — M. Eudoxe Marcille,'' *Gazette des Beaux-Arts* IV (September 1890): 217-35, and (October 1890): 296-310; also George Duplessis, ''La Collection de M. Camille Marcille,'' *Gazette des Beaux-Arts* XIII (March 1876): 419-39.

25. McCoubrey, *Studies in French,* p. 170. Camille Marcille was a director of the Musée de Chartres; Eudoxe, a director of the Musée d'Orléans. The latter also served on Salon juries from 1862 to 1878, giving him access to the art world and acquaintance with many younger painters.

26. For reference to the 1867 sale, see *Collection de M. Laperlier: Tableaux et Dessins de l'Ecole Française du XVIIIe Siècle et de l'Ecole Moderne,* Hôtel Drouot, 11-13 April 1867, with an Introduction by Philippe Burty (Paris, 1867). McCoubrey, *Studies in French,* p. 170, notes Laperlier's collection as the least impressive of the several that contained works by Chardin. Laperlier had many works by Bonvin, some of which were also sold in 1867. See as well Philippe Burty, ''Profile d'amateurs: Laurent Laperlier,'' *L'Art* XL (1879): 149ff.

27. For further reference see Weisberg, ''François Bonvin and an Interest,'' pp. 359-60.

28. The French letter reads:

8 février 1851

Monsieur,

Je me suis empressé d'aller voir les deux Chardins des Jeûneurs. Le premier, *la Pourvoyeuse,* est beau, très beau, et de bonne espèce, malgré des retouches maladroites faites à la figure, au bras droit, un peu au tablier, et au bas violet.

Le second, qui a dû être de Chardin, n'en est plus, pour moi; car ce tableau a dû être entièrement repeint par un prétentieux imbécile, qui a complètement recouvert le maître. Le dessus de la table, les cartes, l'habit du grand garçon, touché maigrement et égratigné, les souliers, les deux têtes des enfants, rouges briquetées et bêtement touchées, tout cela, j'en réponds, n'est pas de Chardin, ou n'est plus de Chardin. *La Pourvoyeuse,* voilà ce que je trouve digne de votre convoitise et digne de Chardin et, malgré la vigueur, l'harmonie et la brillante couleur de l'autre, qui a dû être un chef d'oeuvre, je me permettrai de vous dire, Monsieur, ne le prenez pas; vous dépareriez votre collection.

Votre tout dévoué,

F. Bonvin

The present location of this letter is not known, but a transcribed copy has been found in the collection of Etienette Moreau-Nélaton, Paris.

29. Despite his sentimentality, Greuze nonetheless attracted some Realists because of his genuine interest in the lower classes and morality. A Greuze revival did take place during the 1840s and 1850s, although a study of this renewed interest has never been examined by art historians. Frances Haskell, *Rediscoveries in Art: Some Aspects of Taste, Fashion, and Collecting in England and France* (Ithaca, N.Y.: Cornell University Press, 1976), p. 102, notes that Greuze was an artist appreciated by the Marcille family.

30. The French letter reads:

Pendant le règne de Chardin, nos relations, quoique très intéressantes et fort utiles pour mes études, furent bien souvent près d'être rompues à cause des nombreuses écoles que lui faisaient faire les brocanteurs, qui lui fourraient des Chardins en veux-tu en voilà, lesquels Chardins n'étaient, la plupart du temps, pas même des Jeaurats! A chaque acquisition, je recevais une lettre pour aller voir, au magasin à fourrages de Bercy, le nouveau chef d'oeuvre, qu'après examen et discussion, je condamnais inexorablement au rebut. Les marchands me prenaient en grippe et, si parfois M. Marcille père n'était venu à mon

secours, s'en était fait de ma compétence!

Il n'était pas le seul, d'ailleurs, à se tromper sur Chardin, Delacroix, Ingres, Charles Blanc, voire même ce bon M. La Caze partageaient ses illusions.

Delacroix avait deux dessus de portes, — deux toiles de 6, — des *fruits du raisin,* . . . qui n'étaient point des Chardins. Le père Ingres s'est arraché les cheveux pour avoir manqué un dessus de porte que j'avais acheté 40F pour M. Laperlier, pour lui faire une surprise; ce dessus de porte, les arts, très important, ma foi, était signé *Chardin filius,* et ce pauvre M. Ingres, qui n'avait pas lu Diderot, soutenait que Chardin n'ayant pas eu de fils, cette peinture était du père; notez que la touche et le ton étaient dissemblables à la touche et au ton des tableaux du père — Un jour, prière de M. Laperlier d'aller au plus vite chez Ch. Blanc, Rue Laffitte, examiner une toile de Chardin, représentant un enfant couché près d'un panier de raisins renversés, l'enfant broutant une tartine, la chemise retroussée sur son ventre, et pissant en l'air comme un jet d'eau. Je réponds, courrier par courrier, que je n'ai pas besoin de voir la chose pour affirmer qu'elle ne pouvait être du maître, attendu qu'un pareil sujet ne pouvait se traiter sans avoir peint de *chic,* et que Chardin, depuis l'histoire du fusil, en était incapable.

Insistance de l'amateur fougueux et entêté. J'allai Rue Laffitte, où, dès la porte d'entrée, je dis à Ch. Blanc son erreur. Il ne fut pas du tout content de moi; M. Laperlier non plus; mais, plus tard, je trouvai chez un chiffonnier de la Rue de Vanves une plate gravure du dit tableau, imprimée en rouge et signée: Cheneau invt.

Toutes les fois que j'allais chez M. La Caze (presque chaque dimanche d'hiver), nous avions une discussion devant le charmant portrait de l'école française, la *''femme au livre,''* dont le cadre portait le nom de *Chardin*; de même pour cette toile représentant une cruche, des marrons, un pain et une serviette, et qu'il avait également baptisé du même nom, comme si le goût de Chardin aurait toléré une serviette fine dans une composition aussi rustique! . . . Il me disait: ''Vous me chagrinez de débaptiser ainsi mes enfants;'' et moi de lui répondre: ''Vous n'aurez que plus

46

de mérite d'avoir adopté d'aussi charmants inconnus!": et il a retiré sa fausse attribution!

Ce n'était donc point chose facile que d'éduquer un amateur aussi décisif que l'était M. Laperlier, et je ne trouvai qu'un moyen, qui fut d'obtenir du bon et serviable M. Marcille qu'il consentît à nous prêter ses Chardins les uns après les autres. Ce fut d'abord *le Dessinateur*, puis *l'Ecureuse*, et enfin *le Cabaretier*, que M. Laperlier a fait lithographier à ses frais par Soulange-Tessier, qui faisait mou et qui était bien le plus bête de tous les lithographes.

Mon moyen réussit à merveille et, à partir de cette période, la révélation fut complète. M. Laperlier devint plus compétent qu'aucun autre amateur et le prouva par ses acquisitions hors ligne des *dessus de ports* d'E André, de *la Pourvoyeuse*, du *Jeu d'oie*, du *Devant de cheminée*, pour lequel il fit sculpter en bois une fausse cheminée Louis XV, et de toutes sortes de natures mortes de premier ordre. Je le poussai un peu aussi vers l'école espagnole, pour le fortifier dans la peinture puissante et solide; mais il se lia avec Müller, puis avec son élève Carraud, qui signe si mal et si gros, puis enfin avec . . . Lazerges. Cet éclectisme me lassa et, peu à peu, nos relations cessèrent. . . .

The current location of the original is not known, but a transcribed copy has been found in the collection of Etienette Moreau-Nélaton, Paris.

31. For further information see Paul Mantz, "La Collection La Caze au Musée du Louvre," *Gazette des Beaux-Arts* IV (July 1870): 5-25. According to McCoubrey, *Studies in French*, La Caze had a distinguished collection.

32. For further reference see [Thoré] Bürger, "Exposition de tableaux de l'école française ancienne tirés des collections d'amateurs," *Gazette des Beaux-Arts* VII (1860): 257-77, 330-40; and VIII: 228-40.

33. For further information on the period, see *Second Empire*.

34. McCoubrey, *Studies in French*, pp. 118-19. This point of view is found in Blanc's *Grammaire des Arts du Dessin* (Paris: Librairie Renouard, 1867).

35. Ibid., p. 121. For further reference see *Catalogue des ouvrages de peinture, sculpture, gravure, lithographie et architecture, refusés par le jury de 1863 et exposés par décision de S. M. l'Empereur au Salon*, annexe, Palais des Champs Elysées, 15 May 1863 (Paris, 1863).

36. Jules Antoine Castagnary, *Salons*, 2 vols. (Paris, 1892), 2: 161. The remark was made at the time of the 1863 Salon.

37. McCoubrey, *Studies in French*, p. 136.

38. Ibid.

39. Ibid., p. 137.

40. Bonvin was often compared with Chardin in 1849 and 1851 when he exhibited his *Cook* and his *School for Little Orphan Girls* at the Salon. See I. Peisse, "Salon de 1849" and "Salon de 1850, VI," *Feuilleton du Constitutionnel*, 8 July 1849, and 1851, p. 2. This tendency was also apparent in 1869 when Paul de Saint-Victor drew a further parallel between Bonvin's *Hospital Interior* and Chardin's work. See Paul de Saint-Victor, "Beaux-Arts, Salon de 1869," *La Liberté*, 30 May 1869, p. 3. By 1863 Théodule Ribot was compared with Chardin in Saint-Victor's review of his prints exhibition at the Société des Aquafortistes; see Paul de Saint-Victor, "Beaux-Arts, Société des Aquafortistes," *La Presse*, 27 April 1863, p. 1. Reviews of Vollon's still lifes compared him with Chardin; see Jules Claretie, *Peintres et Sculpteurs Contemporains*, vol. 2 (Paris, 1884), p. 205. Some of Rousseau's still lifes reminded critics of examples of Chardin; see Théophile Thoré-Bürger, *Salons de W. Bürger*, 2 vols. (Paris, 1870), 2: 119. At his death Rousseau was acclaimed as the modern Chardin; see "Nécrologie — Ph. Rousseau," *Courrier de l'Art*, 1887, p. 392. Chardin served as a standard by which reviewers could place these artists in a historical context and by which they could measure their achievements. A full examination of critical writings of that period would clarify how these artists were seen to embody ideas and stylistic qualities found in Chardin.

41. When critics used the designation of a "new Chardin" or drew comparison with a quality in Chardin's work, it was not to denigrate a Realist painter.

42. For information on Bonvin's interest in past masters", see Weisberg, "François Bonvin and an Interest"; and "The Traditional Realism of François Bonvin," *Bulletin of The Cleveland Museum of Art* LXV, no. 9 (November 1978): 280-98.

43. For information on the Le Nain family see Stanley Meltzoff, "The Revival of the Le Nains," *Art Bulletin* XXIV (1942): 259-86.

44. See Gabriel P. Weisberg, *François Bonvin: La Vie et l'oeuvre* (Paris: Editions Geoffroy-Dechaume, 1979).

45. Weisberg, "Traditional Realism," pp. 292-95.

46. Thoré-Bürger, *Salons de W. Bürger*, 2:119.

47. This painting was shown at the Salon of 1867 but is now lost.

48. McCoubrey, "Revival of Chardin," p. 48.

49. For further information see Gabriel P. Weisberg, "A Still Life by Antoine Vollon: Painter of Two Traditions," *Bulletin of The Detroit Institute of Arts* 56, no. 4 (1978): 222-29.

50. Ribot's interest in Spanish masters influenced his genre and still-life compositions. See Gabriel P. Weisberg, "Théodule Ribot: Popular Imagery and *The Little Milkmaid*," *Bulletin of The Cleveland Museum of Art* LXIII, no. 7 (October 1976): 253-63.

51. For Cals's early still lifes see Charles Cunningham, *Jongkind and the Pre-Impressionists: Painters of the Ecole Saint-Siméon*, exh. cat. (Williamstown, Mass.: Sterling and Francine Clark Art Institute and Smith College of Art, 1977), pp. 78-80.

52. For further information on Decamps, see Dewey Mosby, *Alexandre-Gabriel Decamps: 1803-1860*, 2 vols. (Ph.D. diss., Harvard University, 1973; New York: Garland Publishers, 1977).

53. See Emile Zola, *Mes Haines* (Paris, n.d. [1890]), pp. 225-30.

54. McCoubrey, "Revival of Chardin," p. 49.

Themes of Nineteenth Century Still Life

Throughout most of the nineteenth century, still-life painters relied on thematic categories that were already established. Even though canvases were seldom displayed according to subject at the Salon exhibitions or in private galleries, it was generally understood that preference would be given to conventional types of imagery that were already fully accepted as part of art tradition or those modifications of such imagery that involved simply new compositional arrangements of traditional themes. The changes that occurred in the development of still life, the individual artists that influenced a specific category, and certain modifications or tendencies within a particular category can best be discerned and appreciated by evaluating each of the categories separately. It is clear, however, that one category — familiar objects — emerged as the most original category of the period and the one which most painters preferred.

Flower Painting

At mid-century, the theme of flower painting predominated in still life.[1] Canvases of flowers in vases required competence and expertise to execute and were considered a safe, tasteful category to convey the elegant, aristocratic atmosphere that appealed to public, connoisseurs, and critics alike. Many painters tried to re-create a courtly environment through rich, Romantic renditions of brimming vases displayed on a buffet or in a section of a room. Ironically, flower themes were practiced by many artists who were also regarded as emulators of Chardin, even though the eighteenth-century master had never been fully interested in this category.[2] Blaise Desgoffe (1830-1901) excelled in flower compositions, winning admiration from numerous Second Empire collectors for his large-scale decorative canvases, which were appropriate additions to the dining rooms and drawing rooms of that period.

Antoine Vollon did innumerable arrangements of flowers, often using a filled vase placed among a selection of individual portions of fruit to create a setting of simulated abundance. Such a lush, decorative atmosphere conveyed a Romantic ambience of color, rather than a detailed rendering of nature. Occasionally, Vollon placed his flowers within a more humble setting (Fig. 30), arranging objects upon a patch of grass or earth to indicate observation in natural light. The tactile surface of his compositions, however, is also akin to the color innovations introduced earlier by the foremost painter of the Romantic movement, Eugène Delacroix (1798-1863).[3] Thus, Vollon's still lifes became an effective melding of both Realism and Romanticism.

Some painters of flowers followed a different tradition — one of microscopic exactitude that aroused the simplest type of art appreciation.[4] By studying the innovations of seventeenth-century Dutch [1] and Flemish (e.g., Jan van Huysum) artists, some artists developed an objective rendering of the truth. They considered themselves Realists, for they were attempting to record what they saw with the skill of a botanist and the objectivity of a photographer. Many of Henri Fantin-Latour's still lifes of the 1860s are examples of this type of re-creation.

Fantin-Latour tried to render the tangible quality of a strawberry or an orange by first building up the paint surface to suggest the skin of the fruit, and by minutely and carefully recording — in thick paint — every detail on the surface of an object. This photographic effect is based as much on a study of earlier Netherlandish masters as on the Dutch painters of the seventeenth century.[5] Whether capturing the reflection of light from the surface of a glass vase, or intimating the roundness of an orange observed in direct light, Fantin-Latour revealed an innate ability to give his shapes a "real" presence. In his *Flowers and Fruit*, 1866 [20], he used a "dark, plum-brown table cloth on which to display his objects, rather than the [traditional] bright white cloth or the shining wood table-top . . . ," avoiding "stronger reflections and tonal contrasts."[6] His flower paintings are reserved, genteel, and muted — a direct contrast to the vigorous studies of Vollon.

Still-life flower painting in mid-century was also the pursuit of a solitary and mys-

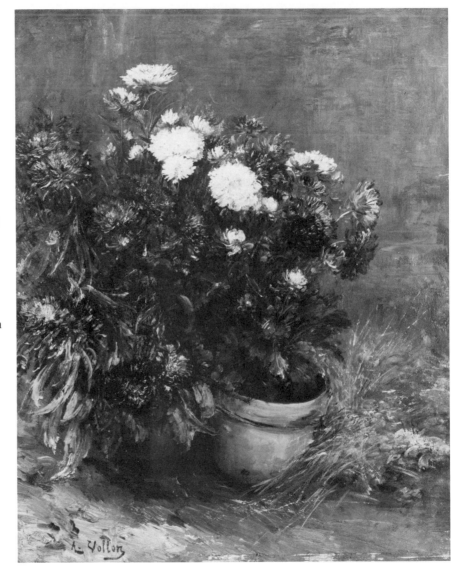

Figure 30. Antoine Vollon, *Still Life with Flower Pots*.

49

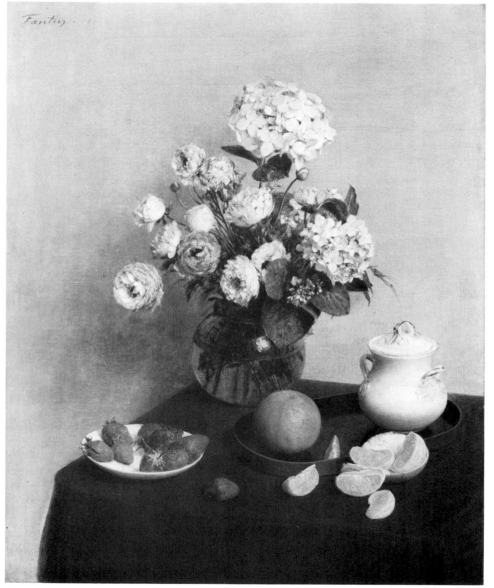

terious watercolorist, Léon Bonvin (1834-1866). Léon Bonvin's (brother of the Realist François Bonvin) career was short, for he committed suicide in 1866, and only a series of water colors remain (Fig. 31).[7] Léon Bonvin's meticulous studies reproduce subtle nuances of light and shade and accurately record specific flower types. The realism achieved by Léon Bonvin and Fantin-Latour and other Realist painters is a direction in still life that developed along with a pervasive interest in Chardin during that period.

Other still-life artists, such as Gustave Courbet (1819-1877), used traditional still-life flower arrangements to create increasingly personal renditions. Gustave Caillebotte (1848-1894), for example, developed a landscape garden scene that focused upon a still-life cluster of blooms in the foreground (Fig. 32). The trend away from intense realism during the 1880s was typified by the innovations of Vincent van Gogh, who preferred to create flower canvases infused with personal symbolism and emotion.

Thus, for the most part, flower painting as a thematic category remained outside the orbit of Chardin's influence. Its popularity as a category was due to its widespread general appeal and to the eagerness of art patrons who encouraged painters to reproduce objects in a photographic style. As a category, it assumed increasing importance as a means of breaking away from the confines of the strict Salon requirements and, under some painters, contributed significantly to the development of a bravura, painterly style.

Figure 31. Léon Bonvin, *Still Life: Vase of Flowers*.

Figure 32. Gustave Caillebotte, *The House at Gennevilliers*.

Opposite **20** Henri Fantin-Latour, *Flowers and Fruit*.

Trophies of Hunting and Fishing

The nineteenth-century painters also achieved recognition in other categories that had been skillfully developed in the eighteenth century. When a painter, in order to win admission to the Academy, had to demonstrate his skill, he did canvases of animals and fruit. The ability to depict animals was considered a part of the basic repertoire of a young still-life painter. Thus, canvases of pheasants, rabbits, partridges, and fish — in short, dead game — became increasingly popular subjects. Still-life painters of the nineteenth century maintained this tradition by following the innovations of Chardin and others and by demonstrating a mastery of technique when they painted "dead" forms.

During the eighteenth century, Nicolas de Largillière helped establish the study of game by placing birds in an architectural niche, as if they were prized objects [4]. Largillière depicted his animals in minute detail to record the observable qualities of their natural existence, but also hung his game to "ripen" where their wild quality both contrasted with, and enriched, the natural ripeness, the color, and the flavor of a selection of fruit. Such hunting and fishing still lifes thus conveyed not only the rewards of the hunt, but also signified the anticipated fulfillment of tasting these morsels at a banquet. Sometimes, dead game was represented as the trophy of a difficult catch, presented in a rustic setting alongside

52

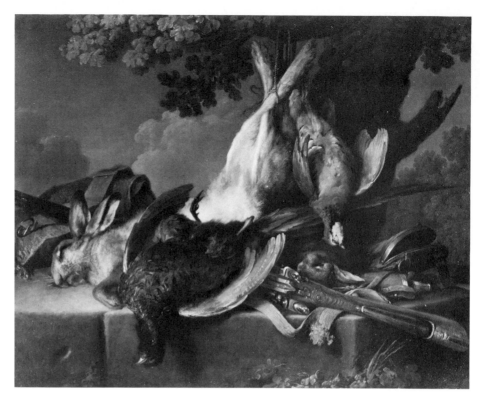

Figure 33. Anne Vallayer-Coster, *Still Life with Game*.

the gun that might have been used to shoot the pheasant or rabbit (Fig. 33).[8]

Studies of game or meat alone were also completed, permitting an artist such as Oudry to use his animals as a pretext to demonstrate his unusually refined illusionistic skills. His dead hare and leg of lamb dangling freely from a hook [5] appear to be suspended in space — a *trompe-l'oeil* effect

that characterized much of Oudry's work and contributed to his popularity. Indeed, Oudry used this compositional format to show how he could deceive the eye into believing that the animals were actually suspended in mid-air. The amazingly realistic rendering of the hare's fur and the texture of the raw lamb typify Oudry's innovative technical skill and daring.[9] A contemporary

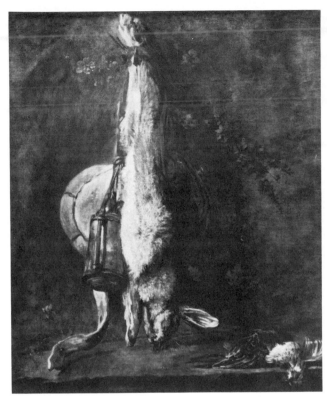

Figure 34. Jean Siméon Chardin,
Wild Rabbit with Game Bag, Powder Flask, Thrush, and Lark.

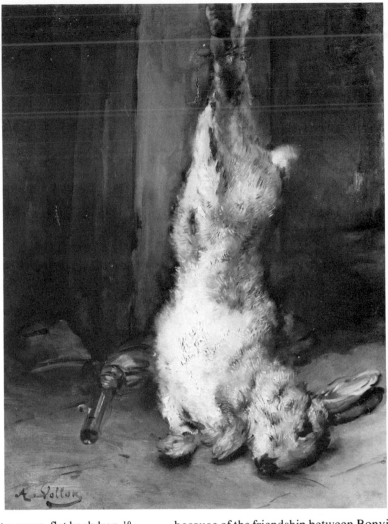

30 Antoine Vollon, *The Rabbit.*

of Chardin, he, too, was considered a master to emulate, and some nineteenth-century painters attempted to simulate his naturalistic space and realistic technique.

Chardin also did studies of trophies of the hunt or illusionistic canvases of birds suspended against a spare, flat backdrop.[10] Some of these compositions are recorded as part of the Marcille collection at an early date, and probably served as the source of inspiration for several nineteenth-century painters to whom they were made available because of the friendship between Bonvin and Marcille. Chardin's *Wild Rabbit with Game Bag, Powder Flask, Thrush, and Lark* (Fig. 34) undoubtedly served as a model for comparable works by Antoine Vollon [**30**] and Eugène Boudin [**14**].

53

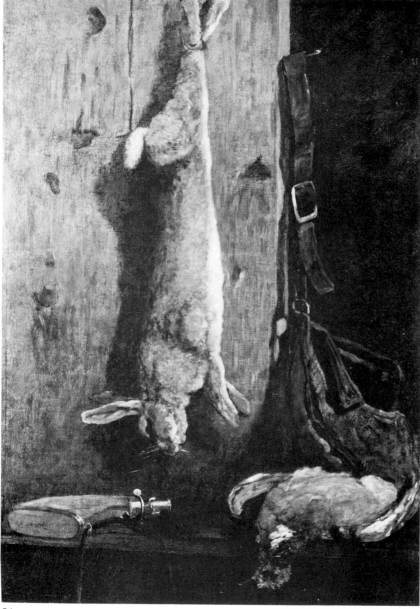

14 Eugène Boudin,
Still Life with Rabbit and Game Bag.

Some nineteenth-century still-life painters regarded the rabbit as one of the first objects to be mastered. In this respect both Boudin and Vollon studied the works and methods of Chardin as they tried to complete serious studies of this particular animal. While Boudin used the same types of objects as Chardin, his composition was not an imitation but rather a modification of Chardin's arrangement (Fig. 34).[11] Boudin's version is much sketchier than Chardin's, for Boudin was interested in capturing the visual effect of the fur on a rabbit, instead of achieving the minute detail of each hair [14]. Boudin's work suggests the freer method of the nineteenth-century progressive painters who wanted to move away from "exact" representation toward an "impression" — quickly perceived — of what dead game looked like.[12]

Vollon followed a similar format, de-emphasizing the subsidiary details of the game bag or hunting pouch to study the rabbit alone. The freer execution, especially in the background, again coincides with the tendency to avoid minute detailing and to pursue the sketch as a finished work in itself [30].[13] Vollon does indicate some detail of the rabbit's fur, but he uses Chardin's method of reality only as a starting point for his own examination of inanimate objects. In other studies of birds (Fig. 35) or dead game, Vollon's method often became

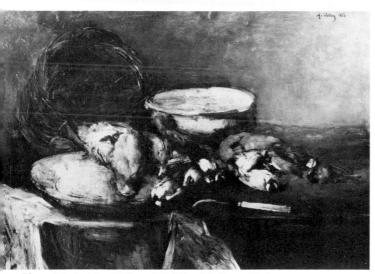

Figure 35. Antoine Vollon, *Still Life with Game Birds*.

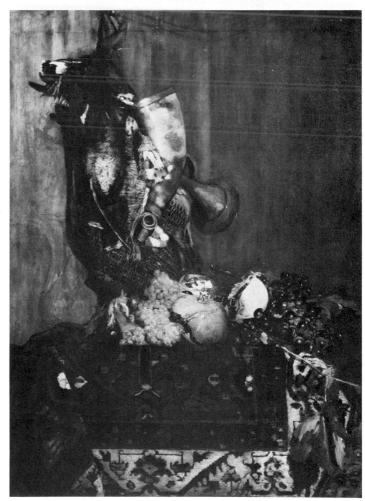

Figure 36. Antoine Vollon, *Trophy of the Hunt and Raisins*.

less constrained and looser, so that the fur or feathers dissolved in a field of color and shimmering light in much the same manner that the Impressionists preferred. The occasional piece that Vollon painted with precise detail, however, may suggest an equal debt to Dutch seventeenth-century painters as well as to Chardin (Fig. 36).

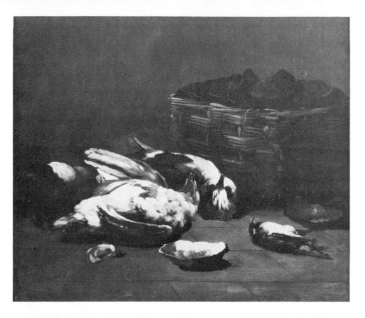

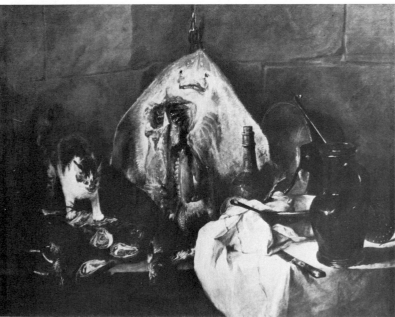

24 Germain Ribot, *Oysters and Partridges*.
See also color plate.

Dead game continued as a theme
throughout the century. Well after 1875 it
was still practiced by artists of traditional
orientation, who positioned birds in spatial
settings that not only suggested arrange-
ments by Chardin but which also echoed
the French heritage of the eighteenth cen-
tury. Germain Ribot's (1845-1893) small
canvas of dead birds is a rare example of his
work that shows this combination of tradi-
tional influences [24].[14]

In addition to animals, painters of the
eighteenth century also studied the attri-
butes of fishing. In 1728 Chardin exhibited
his famous *Ray-Fish* (Fig. 37), which be-
came an exemplar of realism because of its
detail and precision. Other painters, such as
Oudry, also painted studies of fish that, in
turn, served as models for nineteenth- cen-
tury artists.

By the middle of the nineteenth century,
Eugène Lepoittevin, a painter known to
have made studies after eighteenth-century
masters (e.g., Greuze), did a still life show-
ing a ray and an eel suspended on a stone-
work column. The pair appear to be sea
trophies, hung on the wall for others to ad-
mire or purchase [21].[15] The realistic detail,

Figure 37. Jean Siméon Chardin, *The Ray-Fish*
(also called *Kitchen Interior*).

the direct lighting, and the elongation effected by their placement exemplify the increasing interest in the use of fish in still lifes of dead game even earlier than the better known canvases completed by Manet in the mid-1860s.[16]

During the 1860s and 1870s Vollon also favored this theme, randomly placing several kinds of fish on a bare tabletop [28], in a fashion reminiscent of Dutch or Flemish market stalls, where fresh fish were often offered for sale amid a profusion of other foodstuffs. In Vollon's canvases, the fish appear still in motion — captured in "life" as well as in form — squirming and tumbling out of their containers, and different species are often grouped together — perhaps to suggest the abundance of nature. Vollon's fish are also freely painted, indicating that he adopted the same technical, Impressionistic approach that he used in several other categories of still life.

By the end of the century, the interest in fish as a variation of the study of game also interested American painters in Paris.[17] Sören-Emil Carlsen's (1853-1932) study of a fish [16] shows broad brushstrokes that are more suggestive of Vollon than the detailed precision of earlier masters. Carlsen's high color tone may be due to the influence of Chardin but may also be related to the impact of contemporary Impressionists. The sparingly arranged objects, which are carefully, almost studiously composed, and the asymmetrical balance of the forms show the

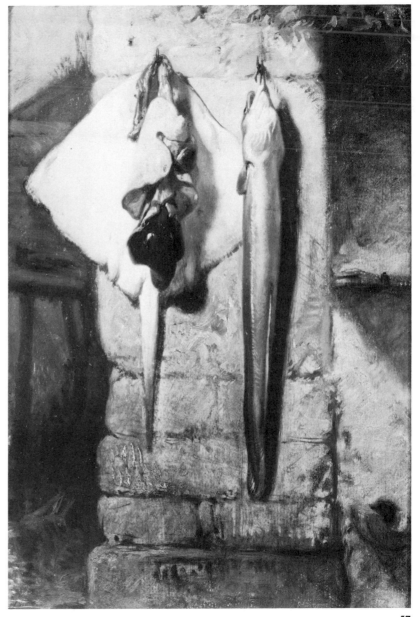

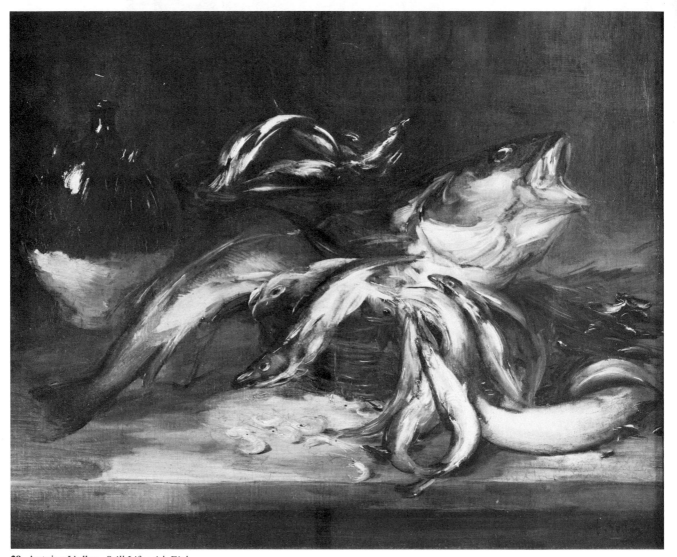

28 Antoine Vollon, *Still Life with Fish*.

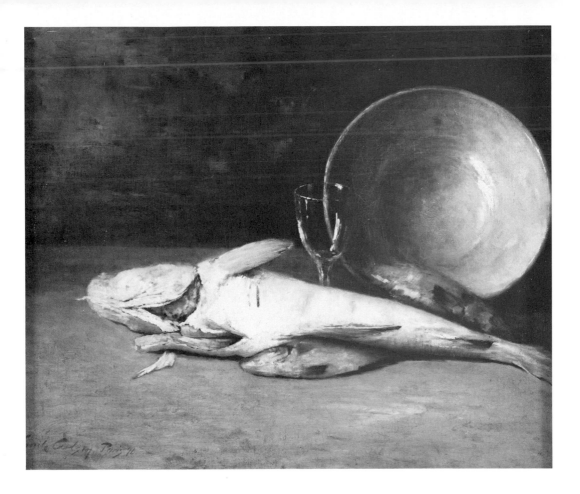

16 Sören-Emil Carlsen, *Still Life*.

influence of new design elements and the beginning of the tendency toward painterly abstraction that became the heritage of more adventurous painters during the twentieth century.

Curiously — and for a longer period of time than has been suspected — the tradition of dead game persisted as a basic category for still-life painting. Reasons for this lie in the connotations of manliness which this theme suggested. The artists who favored hunting and fishing themes relied on the compositional formats achieved earlier, but they began to make formalistic changes even within this traditional category.

Vanitas and Allegory

A third category occasionally used by still-life painters was that of the *vanitas* (themes of mortality and transitoriness).[18] Developed in the seventeenth century and used by artists in the eighteenth century, this theme underscored the meaninglessness of existence. Despite an awareness of the theme in the eighteenth century, however, it was neither popular nor widespread among independent still-life artists during its revival in the nineteenth century.

One work by Vollon shows a skull in the background of a series of books and glass containers found in an artist's (or scholar's) atelier [27]. While Vollon, in this earlier

27 Antoine Vollon,
Still Life with Skull.

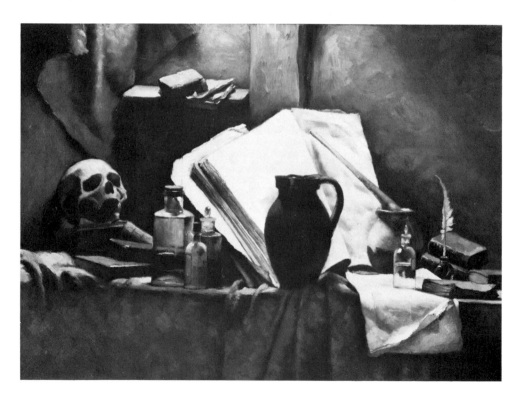

work, may have had a deeper meaning in mind, it is also apparent that the composition is brought together from among the objects that he had available in his own studio. Hence, the random placement of these forms may have been intended as little more than direct observation; the skull was a teaching aid for any young artist learning anatomy just as much as it was a symbol of the frailty of life.[19] Yet, the symbolic allusions do remain, making this unusual still life both objective and ambiguous.

Other images intended as allegories were painted by the Romantic-Orientalist Alexandre-Gabriel Decamps (1803-1860). Late in his career, during the mid-1850s, Decamps received recognition at the Salons for his detailed Oriental scenes. On his own, however, Decamps developed allegorical themes (e.g., *Death and the Woodcutter,* derived from a fable by La Fontaine) or did genre studies of the wretched conditions of the poor.[20] Decamps also painted several still lifes for the dining room of his home at Fontainebleau that suggest his familiarity with the broadening examination of Chardin [**18, 19**].[21] Decamps was even occasionally mentioned during this period as having an interest in Chardin. The schematic arrangement, however, suggests a deeper symbolic intent, rather than the purely visual interest that Chardin maintained in recording what he saw.

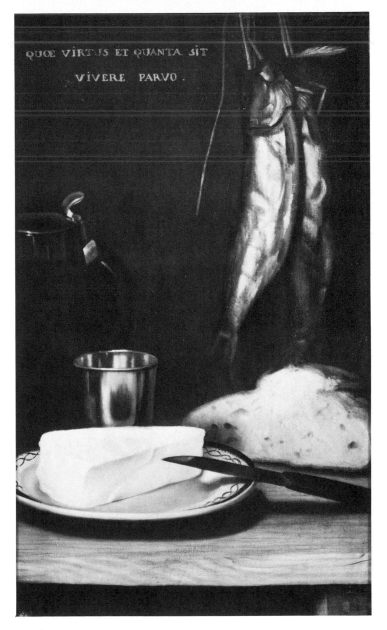

18 Alexandre Decamps, *Still Life.*

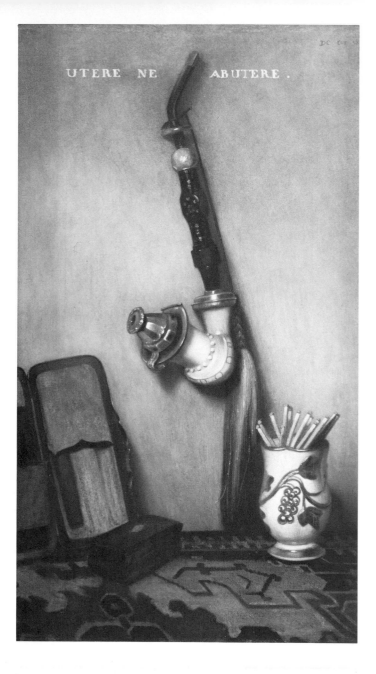

UTERE NE ABUTERE.

Both still lifes make use of Latin inscriptions at the top of the painted image to reinforce the moral depicted. The motto, which can be translated as It Is Virtuous And Great To Live On Little, emphasizes the simple meal presented: a pair of herring, a portion of an open loaf of bread, a wedge of soft cheese with serving knife, and an empty tumbler ready to be filled from the pitcher [**18**]. Whether the objects allude to Biblical or religious meanings is uncertain, although the benefits of moderation and simple pleasures — such as daily bread — are reinforced by a meal that is carefully arranged on a spare, wooden plank that functions as a peasant table. The second still life is captioned Use — Don't Abuse, and highlights an after-dinner pleasure at the same time cautioning against overindulgence [**19**]. Here, too, there is the intimation that certain pleasures of life are as fleeting as smoking a special cigar or favorite pipe. The use of attributes that convey overtones about the quality of smoke itself — perhaps to suggest the transitoriness of life — may also have held an additional significance in the nineteenth century that is no longer understood.

Both paintings, and especially the still life with the Dutch pipe, demonstrate that Decamps was familiar with the tradition of illusionistic painting. He has shown objects suspended in space or held by a wall-hook;

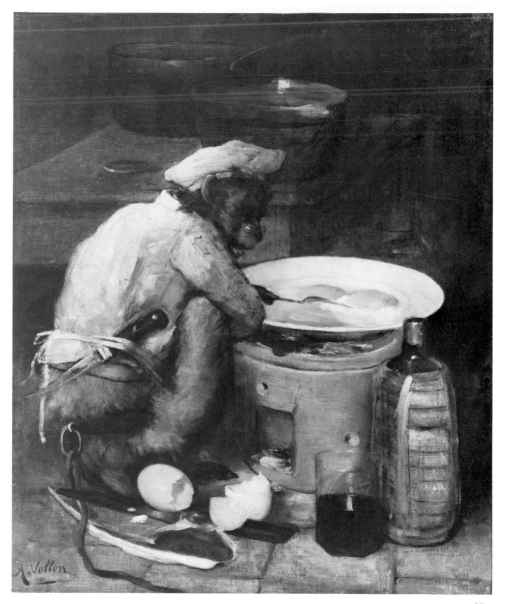

in the case of the Dutch pipe, Decamps created a three-dimensional effect (notice the pipe's shadow on the wall), luring the viewer with a well-conceived *trompe l'oeil*. Decamps was familiar with the work of Chardin, as seen in his placement of some shapes (e.g., the herring or cheese), but his major interest was in the still life as a way to convey an allegorical message. Relying on a carefully composed and selected range of objects, he united allegory with visual illusion to maintain one aspect of still life that was seldom practiced in nineteenth-century France.

Coinciding with the use of allegory was the treatment of another category that Chardin had also used — and one practiced by earlier artists and later by both Decamps and Vollon. In the eighteenth century, parodies of the arts had been continued by Chardin when he used a monkey to symbolize either a painter or a collector.[22] These works, while probably not well known to the general public, remained in a collection in Chartres from 1858 to 1898, where they were accessible only to those few who knew of its existence.[23] While the exact meaning of the use of a monkey is unclear, it has been pointed out that the comparison between painter and ape may have been a disparaging reference to the imitative nature of some artists, who turned to the antique rather than to the study of their own environment.[24]

During the nineteenth century the monkey once again became a popular image, sometimes in the whimsical guise of a connoisseur (as in a work by Decamps) or a cook, as seen in the work by Vollon [31].[25] Even though Flemish *singeries* (pictures in which monkeys are depicted) were popular at the time, Vollon's work — an ambience in which a scholarly monkey is intent upon preparing a meal in a kitchen — reflects his greater propensity for studying Chardin.

Perhaps intended as a caricature of the proliferation of kitchen still lifes at that time, or a jibe at the numerous cooks painted by Realists such as Théodule Ribot, Vollon here has also taken the opportunity to bring out another aspect of his preference for Chardin, without qualifying the message that this composition contains. The painting remains both humorous and tenuous.

Thus, while direct allegory (except the particular type that will be discussed next) was not a major preoccupation of nineteenth-century painters, these few examples suggest that this category of still life was practiced by a few painters who kept the tradition alive.

Figure 38. Jean Siméon Chardin, *Attributes of the Sciences*.

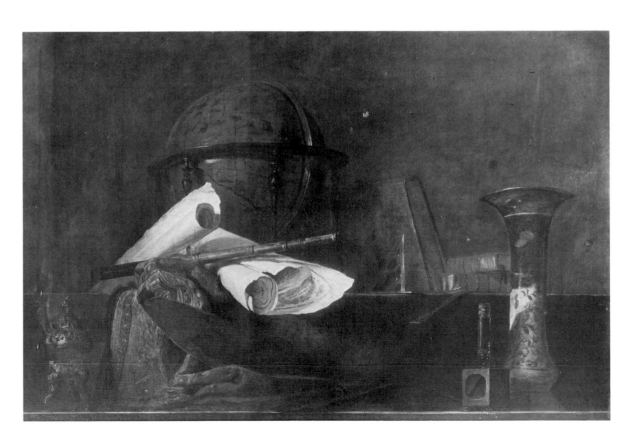

Attributes of Art, Music, and Science

Among the categories that best showed the life of a philosopher, scholar, artist or musician, the attributes of art, music, and science have a long history.[26] Emphasizing pleasurable moments derived from working with new ideas, these canvases often suggested a performance or anticipated creativity. In this sense, they were not as darkly moralistic as the allegories of vanity and, therefore, were adaptable for use as room decorations during the nineteenth century.

Many eighteenth-century painters, including Chardin, completed canvases dedicated to allegories of the arts and sciences.[27] Chardin's earliest examples were once owned by Laperlier, who made them available for study to members of the Realist tradition, including his good friend Bonvin. In addition to Chardin, painters of the eighteenth century such as Thomas-Germain-Joseph Duvivier (1735-1814) developed variations on the arts-and-science allegory. In his *Attributes of Sculpture and Architecture* [2], Duvivier embellished specific examples of artistic creativity. Like Chardin, Duvivier placed his forms on a spare shelf where his objects would be enumerated, including the mallets of a sculptor, an architectural plan, and a plaster cast of a mythological sculpture representing *Leda and the Swan*. The importance of Duvivier's selections and how they reinforced the general allegory of the arts is apparent. It was this attitude, kept alive by

Figure 39. Jean Siméon Chardin, *Attributes of Civilian Music*.

other eighteenth-century masters, which assisted in passing this heritage to painters of the nineteenth century.

This is not to say that Chardin was not instrumental in fostering an interest in this type of allegory (Fig. 38). He completed other examples on the theme of the arts as late as 1765 and 1767, works which were available for study during the Chardin revival in the middle of the next century.[28] Some of these paintings belonged to Marcille (*Attributes of Civilian Music*, 1767; *Attributes of Military Music*, 1767 [Figs. 39, 40]), while others (*Attributes of the Arts*,

Paris, Louvre, 1765, and *Attributes of Music,* Paris, Louvre, 1765) could be seen in the museum or in Fontainebleau.[29] With all of these canvases readily available, Bonvin had many models that may have served as inspiration for his *Attributes of Music,* 1863 [10].

Bonvin's *Attributes of Music* was probably the third in a series dedicated to the arts and should be compared with his *Attributes of Painting* and *Attributes of Sculpture.*[30] The first must have functioned as an overdoor in conjunction with the two vertical companions. The original purpose of these panels was to demonstrate the working process of artists and musicians from a study of their tools — plaster busts, palette, guitar, or cittern. Planned as part of a grouping for a single room, these paintings provided a decorative scheme with a well-established traditional symbolism.

When Bonivin studied Chardin's examples, and, possibly to a lesser degree, compositions by Nicolas-Henry Jeaurat de Bertry [3], it was the clarity of Chardin's spatial arrangements that Bonvin strived to achieve. Jeaurat de Bertry's work may have helped convince Bonvin to limit the number of objects he used, but it was only from Chardin that he could have derived the harmonious integration of these objects in a unified composition. Bonvin used only two musical instruments (a cittern and a flute) in his *Attributes of Music,* conveying the sense of a performance through the natural way in which he positioned his instruments and through the casual impact of the open music book. While the specific personal symbolism contained in this canvas related to Bonvin's own life — and hence moves the work away from pure allegory — he used a longstanding traditional symbolism to develop a category of still life he practiced many times in his career.[31]

Bonvin's use of this type of still life is understandable, given his fondness for Chardin and his close friendship with major collectors. Whether he completed these examples on commission — as part of the new preference for Chardin — is unknown, but certainly few other nineteenth-century still-life painters were as dedicated to this category as Bonvin.

Figure 40. Jean Siméon Chardin, *Attributes of Military Music.*

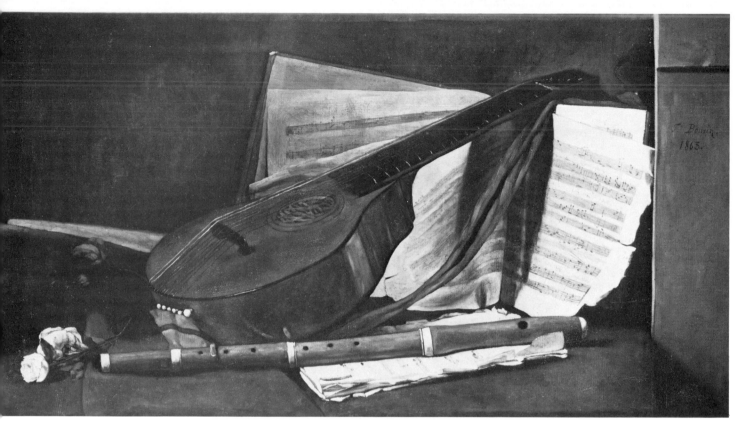

10 François Bonvin, *Attributes of Music*.

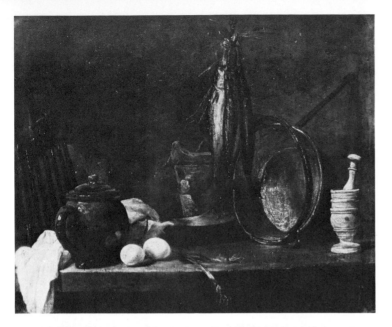

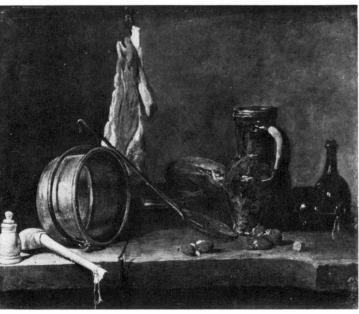

Familiar Objects

By far the most numerous category of still lifes were canvases of "familiar" objects. Despite cries by critics that painters should only record "rare things," painters showed increased interest in the commonplace, with the result that the still lifes rejected at the Salon of 1863 were those judged unfit for the drawing room: studies of carrots, cabbages, asparagus, oysters, onions, eggs, and cooking utensils.[32] Chardin had been among the first to show that paintings of kitchen utensils and humble foods could be included in the repertoire of types developed by a still-life painter. In his small works on copper, *Fast-Day Meal* (Fig. 41) and *Meat-Day Meal* (Fig. 42), he focused on objects intended for everyday use. In the first, he presented a grill, a cooking pan, a pot, a frying pan, an earthenware brazier, and a kettle, and included eggs and leeks in the foreground as food to be prepared for the meal. In the second, he studied a wooden spoon, a pitcher, dark glass bottles, a cut of meat, bread, kidneys, and a metal skimmer, establishing objects that would later be used repeatedly by nineteenth-century painters, who developed a veritable

Figure 41. Jean Siméon Chardin, *Fast-Day Meal*.

Figure 42. Jean Siméon Chardin, *Meat-Day Meal*.

Figure 43. Antoine Vollon,
Still Life with Cauldron.

cult around "familiar objects" used in meal
preparation (Fig. 43). The same artists who
had used Chardin as their guide in other ex-
amples also drew on their own natural ten-
dencies. Such was the case with Bonvin
whose large canvas of a *Copper Cauldron
with a Side of Beef and Leeks* [12] was in-
spired by two sources. On the one hand,
Chardin's *A Quarter of Cutlets on Striped
Linen, a Pitcher, Two Onions . . . ,* 1732, in
the collection of Marcille, may have in-
spired Bonvin's own version of such a
kitchen table.[33] Yet, a more striking similar-
ity exists between Bonvin's work and a
composition by Bounieu, which shows the
same general assortment of ingredients for a
stew (Fig. 44). Curiously, in the nineteenth
century, Bounieu's painting, *Preparations
for a pot-au-feu,* was thought to have been
executed by Chardin, proving that Bonvin's
eye was not infallible when it came to iden-
tifying the canvases of his chosen master.
The arrangement of both works, however,
is so similar (and the purpose so much the
same) that it is doubtful whether Bonvin
could have completed his work without hav-
ing seen Chardin's earlier work as well.
This relationship underscores another as-

Figure 44. Michel-Honoré Bounieu,
Preparations for a pot-au-feu.

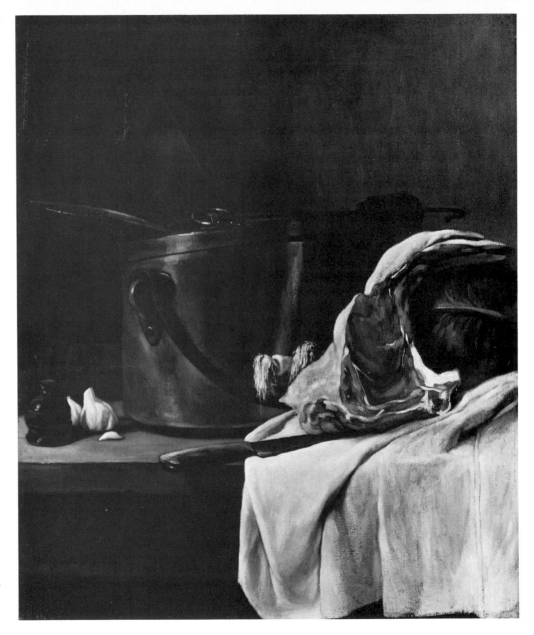

12 François Bonvin,
Still Life.

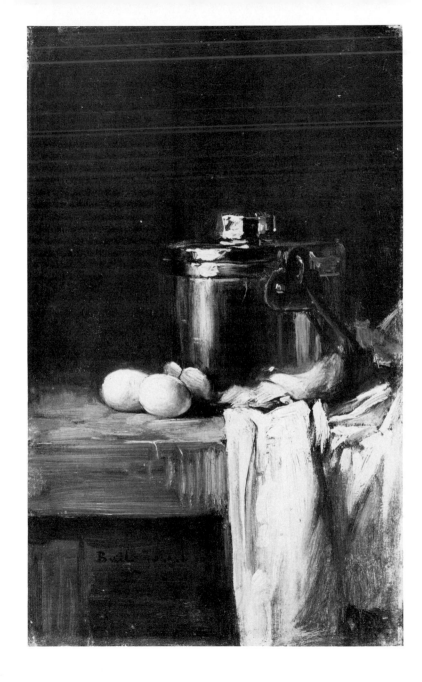

8 Joseph Bail, *Still Life*.
See also color plate.

pect of Realist theory, for the painters of the nineteenth century felt impelled to seek prototypes for their own vision. The belief that Chardin (i.e., the misidentified Bounieu) had chosen to paint food being readied for an ordinary meal led to the creation of a whole series of similar canvases that multiplied with alarming rapidity by the mid-1860s.

Interest in meal preparation remained part of traditional still-life painting late in the century. Later painters such as Joseph Bail (1862-1921) [8] continued to use copper cauldrons that resembled works by Bonvin as much as earlier works by Chardin. The coarser, broader strokes of Bail's paint application, however, indicate that Vollon also influenced the way in which these painters reacted to what they saw.

Even outside of France, Chardin's compositions of fowl or cuts of meat (e.g., *Loin of Meat*) helped maintain the theme of meal preparation in the work of the little known Belgian painter David Emil de Noter (1825-?). De Noter's intimate studies of objects that are focused in the center of a panel show a close examination of the Chardin tradition as it was then emerging in France [22, 23].

Nevertheless, it was essentially the French Realists who adopted Chardin's propensity for common themes to help expand the possibilities of using everyday ob-

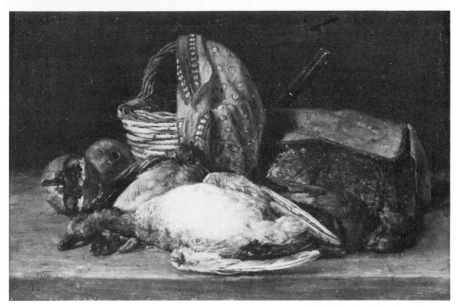

jects. Vollon centered a copper water urn amid a group of objects which were studiously arranged [32]. The contrasting textures of metallic objects and the earthenware containers show a debt to Chardin, but Vollon's freer method is equally apparent. This distinction is even more obvious in his version of another popular theme of the 1860s, a study of oysters, in which the spontaneity of paint application reveals his strong, Romantic qualities [29].

22 David Emil de Noter, *Still Life*.

23 David Emil de Noter,
Still Life.

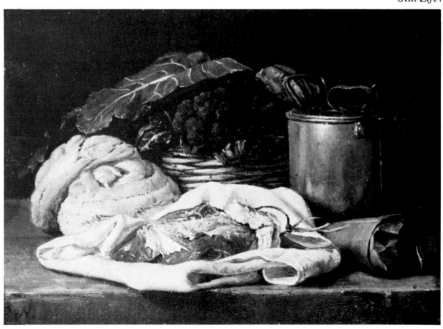

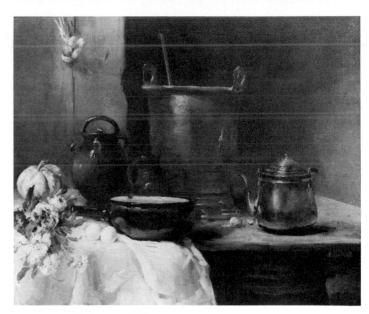

29 Antoine Vollon, *Still Life with Oysters*.

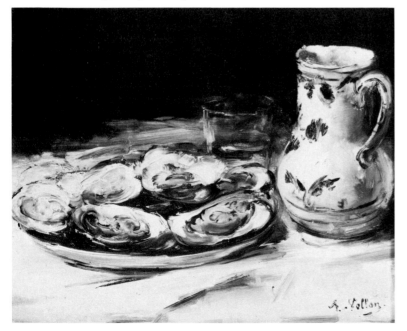

32 Antoine Vollon,
Still Life with Copper Cauldron.
See also color cover.

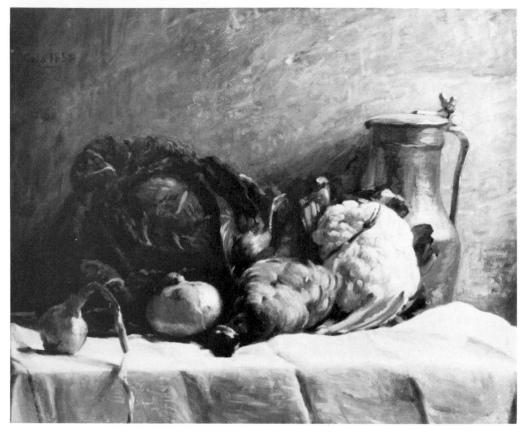

15 Adolphe-Félix Cals,
Still Life.

Other painters, such as Adolphe-Félix Cals, studied objects with a different point in mind. In examination of cabbages, pheasants, onions, or a pewter container, Cals observed his forms in a grayed, subdued light [15]. By simplifying compositions so that he studied only a few objects, Cals's purpose was to portray not only their mealtime associations, but shapes in and of themselves. In this sense, he deviated from the tendencies of some of his compatriots in the still-life revival by bringing out, on occasion, the underlying compositional design principles. The same tendency can be found in the work of Armand Gautier whose study of an open book, glasses, and fabric demonstrates an interest in light and form without apparent narrative associations (Fig. 28). Thus, by working with a minimal number of shapes and while studying light effects in a Realist manner, some painters at mid-century were gradually freeing themselves of traditional ways of seeing or thinking so that they could concentrate on purely formal interests — the way Chardin had done in his finest still lifes. This tendency was highlighted in the canvases of Théodule Ribot, who chose to paint earthenware jugs for their geometric shapes regardless of their utilitarian function. By limiting his color range, by demonstrating the solidity and permanence of his objects, Ribot achieved some of the most innovative

74

25 Théodule Ribot, *Still Life with Ceramics and Eggs*.

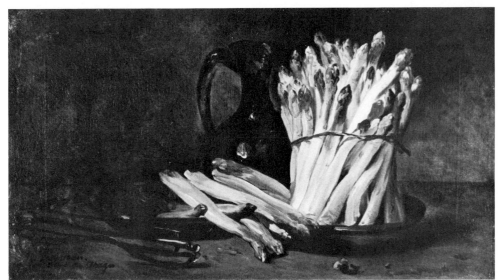

26 Philippe Rousseau, *Asparagus*.

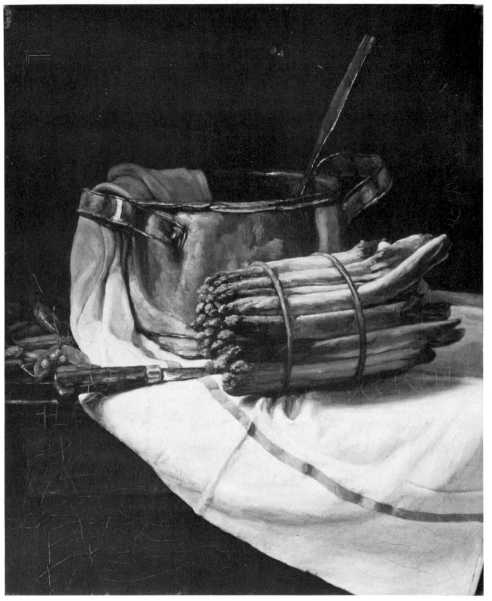

11 François Bonvin,
Still Life with Asparagus.

studies within the Realist tradition. His depictions of unglazed pottery were inspired by earlier Spanish — not French — masters, but the subtle harmony he discovered between shapes anticipates the abstract rhythms and interrelationships that would become much clearer toward the end of the century in the studies of more progressive French painters, such as Cézanne.[34] Thus, although he used familiar objects, Ribot refined the still life by concentrating on purely formal elements [25].

Although it has not been determined with certainty, still lifes of asparagus seem to have been a particular innovation of the nineteenth century. Those who studied asparagus in a kitchen setting revealed an interest in a food that had not been anticipated by earlier painters. Rousseau and Bonvin displayed their technical proficiency by capturing the tactile quality of this popular vegetable. On the one hand, Rousseau used the pliant, tightly budded, tender shoots to evoke delicate mealtime associations [26]; Bonvin, on the other hand, used this basic staple from his garden as part of his lower-class Realism [11]. Within these extremes of examination, Bonvin — like Ribot — recognized the asparagus bunch as a geometric shape that could be contrasted with other objects to create a compositional order based on tensions between objects. In a modern sense,

Bonvin created a unified design by placing his objects at the utmost boundaries of their spatial tensions. Any further, and the objects would topple into disarray: the tenuous relationship between the knife and asparagus would break at the table edge, pulling with it the linen and peapods as well as the ladle within the kettle, clearing away "the arrangement" completely.

While some sought geometric structure in large format, others observed objects directly on a much smaller scale. Many of these smaller still lifes were of familiar fruits and baskets that were reminiscent of Vallayer-Coster's diminutive versions in the eighteenth century [7]. In this category, Denis-Pierre Bergeret (1846-?) did intimate studies of shrimp [9]; Bonvin achieved a close little study of eggs and a ceramic [13]; and Eugène Carrière (1849-1906) uncovered the rhythms found in a napkin, coffeepot, and cup [17]. The tendency to reveal "personal impressions" through a study of familiar objects was modified by the turn of the century. Compositions were simplified, based on observation of ordinary nature, without preconceived patterns or the rigid

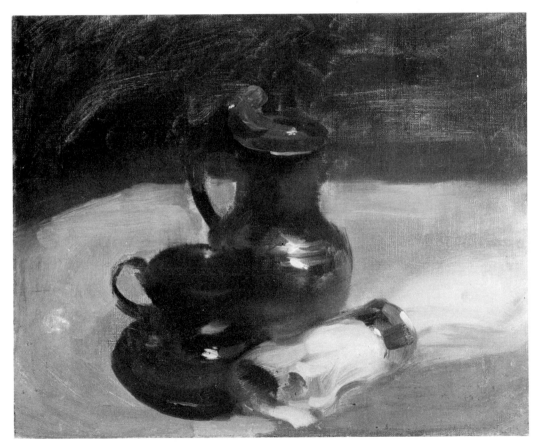

17 Eugène Carrière,
Still Life.

conformity that once required a painter to arrange his shapes in a certain order to please a patron or Salon. The intimate approach of these new studies prepared the way for the discovery of abstract rhythms, leading a painter such as Carrière to limit the number of recognizable still-life objects while seeking other principles of organization for his work. In their subordination of subject matter to formal principles, the still-life painters supported in their work the theoretical concerns of the proponents of ''art-for-art's sake.'' The end results in this direction were the new still lifes of Matisse and the Cubists, in which the structures and decorative rhythms that still-life painters had long been striving for finally reigned supreme.

9 Denis-Pierre Bergeret, *Shrimp*.

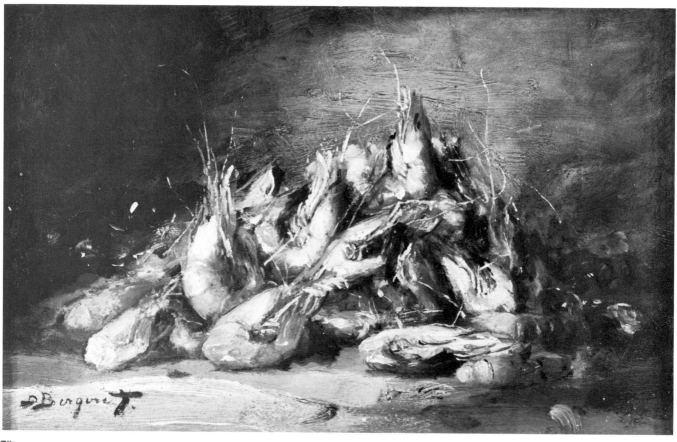

Thus, while the influence of Chardin reverberated well into the twentieth century, the first impact of his achievements came in the middle of the nineteenth century. Without the Realists' support of the Chardin revival and their emphasis upon his contribution, his significance in preparing the way for abstract art would have been minimized. In the process, still life moved away from confining traditional categories toward the development of freer arrangements based on the use of familiar objects. An artist found shapes in his environment and rearranged some still-life objects at will, according to the design principles of a new age. The bonds of Salon categories were thus liberated, allowing new expressions that a classical system based on standardized formulas could never have realized.

13 François Bonvin,
 Still Life.

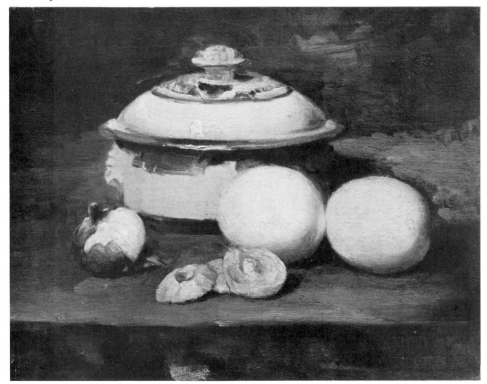

1. John W. McCoubrey, *Studies in French Still-Life Painting, Theory and Criticism: 1660-1860* (Ph.D. diss., New York University, March 1958; Ann Arbor, Mich.: University Microfilms, MIC58-7755), p. 138, notes that flower painting was a dominant category of still life. Without a thorough study of Salon records at mid-century, it may prove difficult to establish accurately how many examples of flower paintings were actually exhibited. See also *The Second Empire: Art in France under Napoleon III*, exh. cat. (Philadelphia: Philadelphia Museum of Art, 1978), p. 299.

2. Chardin did one flower painting, *Bouquet of Carnations, Tuberoses, and Sweet Peas . . . ,* which is reproduced in Rosenberg, *Chardin*, exh. cat. (Paris: Editions de la Réunion des Musées Nationaux, 1979), cat. no. 100. For an examination of eighteenth-century flower painters, see Michael Faré, *La Nature Morte en France*, 2 vols. (Geneva: Pierre Cailler, 1962), 1: 204-8.

3. Gabriel P. Weisberg, "A Still Life by Antoine Vollon: Painter of Two Traditions," *Bulletin of the Detroit Institute of Arts* 56, no. 4 (1978): 222-29. The tactile surface of Vollon's canvas is a quality he definitely derived from the Romantic artists.

4. McCoubrey, *Studies in French*, p. 122.

5. See *Second Empire*, p. 299. A complete examination of Fantin-Latour's interest in Dutch art through study of his group portraits and his still lifes would be valuable.

6. William J. Chiego, "Two Paintings by Fantin-Latour," *Museum News: The Toledo Museum of Art*, n.d. [? 1973].

7. For further reference see Philippe Burty, "Léon Bonvin, l'Aquarelliste," *La Nouvelle Revue*, January 1886, pp. 142-55.

8. For a discussion of this theme, see Faré, *Nature Morte*, 1: 216-21.

9. William S. Talbot, "Jean Baptiste Oudry: Hare and Leg of Lamb," *Bulletin of The Cleveland Museum of Art* LVII, no. 5 (May 1970): 149-58.

10. See Rosenberg, *Chardin*, cat. nos. 17 and 22.

11. For a brief discussion of pastiche and Bonvin, see Gabriel P. Weisberg, "The Traditional Realism of François Bonvin," *Bulletin of The Cleveland Museum of Art* LXV, no. 9 (November 1978): 295-96. A similar interest would have governed the way in which Boudin used Chardin as a model; see Robert Schmit, *Eugène Boudin: 1824-1898*, 3 vols. (Paris: Imprimerie Union, 1973).

12. See Schmit, *Eugène Boudin*.

13. Albert Boime, *The Academy and French Painting in the Nineteenth Century* (London: Phaidon Publishing, 1971), pp. 79-115, 157-84.

14. The works of Germain Ribot (1845-1893), who was less well known that his father Théodule Ribot, have not been fully identified or collected. His work was distinguished from that of his father by the French art dealer André Watteau in the mid-1960s. For reference to Germain, see Douglas Druick and Louise D'Argencourt, eds., *The Other Nineteenth Century: Paintings and Sculpture — Collection of Mr. and Mrs. Joseph M. Tanenbaum* (Ottawa: The National Gallery of Canada, 1978), p. 170.

15. It is not known how many still lifes were done by Lepoittevin, who was best known for his scenes of anecdotal genre. He began to exhibit at the Salon in 1831 and continued until 1869.

16. For information on Manet, see Anne Coffin Hanson, *Edouard Manet — 1832-1883*, exh. cat. (Philadelphia: Philadelphia Museum of Art and the Art Institute of Chicago, 1966). Manet has also been compared with Chardin.

17. See William H. Gerdts and Russell Burke, *American Still-Life Painting* (New York: Praeger Publishers, 1971), pp. 202-4.

18. See Faré, *Nature Morte*, 1:221-23, for the use of this theme in the eighteenth century.

19. Ibid., 1:222.

20. Dewey Mosby, *Alexandre-Gabriel Decamps: 1803-1860*, 2 vols. (Ph.D. diss., Harvard University, 1973; New York: Garland Publishers, 1977), 1:216.

21. Ibid., vol. 1, p. 245; vol. 2, pl. 114a, 114b.

22. See Rosenberg, *Chardin*, cat. nos. 66, 67.

23. Ibid., pp. 222-24.

24. Ibid., p. 224.

25. The origin of the monkey as an image in art, or the possible symbolic intentions that may have led to its common use, has seldom been researched. Critics and commentators during the period when it was a popular theme noted the humorous intention, but failed to speculate on any other possible significance. Monkey images in still life suggest: (1) the exotic combined with the commonplace — a touch of the bizarre; (2) intense animation and mimicry, especially monkey-tricks — imitations of man; and (3) a play upon the whole "copyist" tradition that is familiar in the background of every trained artist. In addition, the monkey may have once symbolized one or several of the senses: sight, touch, taste, smell, hearing, or possibly the sixth sense of intuition.

26. Faré, *Nature Morte*, 1:223-28.

27. See Rosenberg, *Chardin*, cat. no. 30.

28. Ibid., pp. 339-44.

29. Ibid.

30. Weisberg, "Traditional Realism," pp. 292-95.

31. Ibid.

32. McCoubrey, *Studies in French*, p. 121.

33. See Rosenberg, *Chardin*, p. 167, fig. 39.

34. Faré, *Nature Morte*, 1:264.

Biographies
and
Bibliographies

Abraham Hendricksz van Beyeren [1]
1620/21 — 1675 or 1690

Van Beyeren painted two types of still-life compositions which brought him fame during the seventeenth century. On the one hand, he did elaborate studies of flowers, and, on the other, his paintings of fish proved to be exceptionally popular with the middle-class patrons of Holland. Most of his works are seldom signed or initialed. He is mentioned as working in Leyden in 1639 and in The Hague in 1640, although he moved to several other Dutch cities later on, including Delft, Amsterdam, Alkmaar, and Overschie.

Thomas-Germain-Joseph Duvivier [2]
1735 Paris — 1814 Paris

Little is known about the career of Thomas-Germain-Joseph Duvivier except that he was the son of the engraver Jean Duvivier (1687-1761). At some time during his career Duvivier came into contact with Chardin, perhaps even working briefly with him in Chardin's atelier. Like other well-established painters, Duvivier was called upon to paint a canvas recalling Chardin's *Attributes of the Arts*. The result, Duvivier's *Attributes of Sculpture and Architecture*, suggests a use as a decorative panel as much as a work with a traditional allegorical meaning.

Nicolas-Henry Jeaurat de Bertry [3]
1728 Paris — after 1796

Even though he was a student of the history painter Etienne Jeaurat, Nicolas-Henry Jeaurat de Bertry followed a different path to gain admission into the Academy: he became a painter of genre and still life. By 1756 his entrance into the Academy was assured when he completed a work entitled *Kitchen Utensils*. In 1757 he also exhibited three important paintings dedicated to the use of allegorical messages: *Attributes of Music, Attributes of War,* and *Attributes of Science*. As a portrait painter Jeaurat de Bertry also gained fame and fortune when he became the official artist for Marie Leczinska of the Russian court. He continued to exhibit at the Salons until

1796. His still-life compositions have resulted in his recognition today mainly as a follower of Chardin.

Nicolas de Largillière [4]
1656 Paris — 1746 Paris

Nicolas de Largillière was considered one of the leading portraitists during the reign of Louis XIV (along with Hyacinthe Rigaud), as well as a master painter in the category of still life. As a member of the official Academy, Largillière valued drawing above coloring, and portraiture above other painting categories.

Largillière received his training under the artist Goubau in Antwerp by doing innumerable studies of still life that were often added as background accessories to official historical portraits. Eventually he did independent canvases of flowers, fruits, vegetables, and animals, becoming an important still-life painter in his own right. At eighteen Largillière went to England, where he received strong support from the royal family. He returned to Paris in 1680 where he was soon established as an academician of portraits. He reached the height of his profession through official commissions. Undoubtedly he regarded still life only as a means of gaining funds or displaying his skills, but even though his still lifes are exceedingly rare, they display a technical proficiency and a firm knowledge of previous traditions.

Jean Baptiste Oudry [5]
1686 Paris — 1755 Beauvais

As the most famous animal and still-life painter in the mid-eighteenth century Jean Baptiste Oudry — along with Chardin — must be credited with having revolutionized the category of genre and still-life painting. Trained under Nicolas de Largillière, Oudry came to Paris, where by 1717 he was also completing portraits for wealthy patrons. Oudry's rise to prominence was rapid: by the 1720s King Louis XV commissioned him to complete five paintings to illustrate the *Fables choisies* of La Fontaine. Gaining the friendship

of the royal family, and especially Louis XV, Oudry became, in effect, the court painter of dogs, a theme which made full use of his remarkable naturalistic talents. Oudry also decorated many of the official apartments of the royal family, another indication of his position as a major painter to the court.

During the 1730s, Oudry became an exceptionally successful painter whose fortune was assured and whose social position was secured. Often Oudry escaped from the confining formalities of the Parisian court to Beauvais, where he maintained an elegant chateau and where he worked with decorators at the tapestry manufactory in the production of suitable designs for decorative ensembles. Oudry was also an impressive portraitist whose work was sought by leading aristocratic families, for Oudry's portraits were exact and often remarkably lifelike renderings.

Oudry was a prodigious worker — so much so that he was often criticized for not having finished himself many of the paintings that he said had been produced by his own hand. Whether this is true remains to be examined; certainly when he exhibited as many as fifteen paintings at a given Salon (1753), it seems likely that he may have had students or assistants working with him. An inventory of Oudry's work now lists more than three thousand examples, which can be divided into still lifes, portraits, landscapes, genre scenes, and animal scenes. He was a master of *trompe-l'oeil* effects and continually sought new devices to deceive the eye of a beholder, since many of his compositions were used as part of room decorations intended to open up the interior space of an apartment. Painters in the nineteenth century were aware of his significance and studied his work almost as much as the compositions of Chardin.

Henri Horace Roland de la Porte [6]
1725 Paris — 1793

As a painter of still life, Henri Horace Roland de la Porte exhibited regularly at the Salons from 1761 until 1789. In 1763 he received recognition as an outstanding painter of animal themes when he was named an Academician in the Institute. He painted innumerable flower studies combined with elaborate objects, although he also did compositions of fruit on a simpler scale. Unlike Chardin, Roland de la Porte's work is distinguished by Flemish influences as well as by purely French tradition.

Anne Vallayer-Coster [7]
1744 Paris — 1818 Paris

As an active painter of still life, genre, and portrait paintings, Anne Vallayer-Coster is considered a follower of the style of Chardin. Interestingly, some of her works may have at one time been attributed to Chardin, and it is only in recent years that she has been accorded distinction in her own right. Her small, intimate studies of fruit on a plain table owe much to the innovations and compositional format of her still-life colleagues. Vallayer-Coster is important for another reason: she was one of the more active feminine painters of the eighteenth century who succeeded in developing her own career, winning acceptance to the Royal Academy of Painting in July 1770. While an exact record of Vallayer-Coster's work has not been compiled, she participated in the Salons from 1771 until 1817.

Joseph Bail [8]
1862 Limonest, Rhône — 1921 Paris

As the youngest son of the painter Antoine Jean Bail (1839-1918), Joseph Bail was exposed to the Romantic heritage of painting in Lyons as well as the development of Realist art from the canvases of his father. Trained under his father's watchful eye, and later in the academic studios of Jean Léon Gérôme and Carolus Duran, Bail exhibited for the first time in 1878 at the Salon des Artistes Français. Throughout the 1880s, Bail painted genre scenes, studies of animals, and still lifes, all of which revealed a knowledge of previous painters, such as Chardin, as well as painters in the Realist tradition. His best-known canvases included a series of cooks, suggesting that Bail was familiar with the work of Théodule Ribot and perhaps was attempting to achieve the same degree of popularity with a similar theme.

Bail's compositions that were shown at the Salon were favorably received during the Third Republic and he obtained an honorable mention (1885); a third-class medal (1886); a second-class medal (1887); a silver medal at the World's Fair (1889); and a gold medal (1900). Because Bail pursued a traditional type of painting, based on earlier models, the middle class found his canvases attractive and appealing. His works show a knowledge of light, for he often posed figures in silhouette against a brilliant light source. Bail, however, was not interested in an analysis of abstract form. In 1902 he received a medal of honor for his dedication to the Realist aesthetic.

Bibliography
Valmy-Baysse, J. *Peintres d'aujourd'hui, Joseph Bail.* Paris, 1910.

Denis-Pierre Bergeret [9]
1846 Villeparisis — ?

Denis-Pierre Bergeret became one of the most popular and prolific painters of still life during the Third Republic. Trained under Eugène Isabey, Bergeret combined an intense Romantic coloring with a Realist's interest in carefully observed form. Undoubtedly, he was influenced by the canvases of Antoine Vollon [27-32], since he used a similarly thick paint impasto applied with a vigorous brushstroke. Bergeret first exhibited in the 1870 Salon and regularly thereafter until 1908, completing compositions of standard genre and still-life themes that included flowers and fruit, asparagus, plums, fish, rabbits, and shrimp [9]. He received a third-class medal (1873) for his painting *Lobster;* a second-class medal (1877) for *Shrimp;* and, as commendation for his artistry in general, a medal of honor at the World's Fair in

1889, and another at the Paris Fair in 1900. Bergeret seems to have painted few other themes, devoting his career to popularizing still life.

François Saint Bonvin [10-13]
1817 Vaugirard (Paris) Figures 24, 27
— 1887 Saint-Germain-en-Laye

François Saint Bonvin was a self-taught artist. His earliest known oil painting (1839) forecasts a lifelong dedication to still life. Because he was working for the Paris Préfecture de Police at the time, this first panel was probably completed at night, after the day's responsibilities. What little training Bonvin obtained, first as a printer and later on his own at the Académie Suisse, was augmented by contact with François-Marius Granet (1775-1849), the artist Bonvin considered his master. During the early 1840s, Bonvin advocated themes drawn from everyday life, especially scenes inspired by family and close friends.

In an effort to win recognition, Bonvin exhibited drawings and water colors under the arcades of the Institut de France from 1844 to 1846, where his first patron, Laurent Laperlier, purchased some drawings. His first Salon exhibition, in 1847, was a portrait.

Because of his interests and his association with other Realists, Bonvin met, among others, the novelist and critic Champfleury and the artist Gustave Courbet (1819-1877), with whom he developed a fruitful relationship which was to last until the mid-1860s. They used to meet in Parisian cafés to discuss and exchange ideas about the course of French painting. Champfleury championed Bonvin's still lifes; and at the Salon of 1849 he singled out *The Cook* as sharing affinities with the work of Jean Siméon Chardin (1699-1779), a master whose works Bonvin admired at the Louvre and in private collections in Paris. This painting received a third-class medal, and the artist was awarded 250 francs which helped alleviate his poverty.

Bonvin's small compositions never generated the fervent critical attacks by conservative critics that were directed against Courbet's new Realist imagery. For this reason Bonvin received an official state commission to complete *The School for Orphan Girls* (1851 Salon), which received a second-class medal — the highest award Bonvin ever received.

During the Second Empire, Bonvin obtained considerable support. Commissions and purchases of his images of contemporary themes helped establish him as a key figure in the emergence of Naturalism. These works reflected none of the harsh stylistic changes advocated by Courbet. In 1859, when a number of young painters were rejected at the Salon, Bonvin exhibited their works in his own studio, thereby actively supporting Alphonse Legros (1837-1911), Henri Fantin-Latour [20], James McNeill Whistler (1834-1903), and Théodule Ribot [25], in spite of conservative opposition by critics to increasingly naturalistic images.

Bonvin's work reveals a sympathetic understanding of painters from former times, especially the Dutch masters of the seventeenth century. His examination of their themes helped provide a foundation for French advocacy of a similar practical aesthetic. In 1866, following the suicide of his artistically talented half brother Léon, Bonvin made his first trip to the Low Countries, visiting Holland in 1867, to fulfill a lifelong admiration for those painters he had first studied in the Louvre.

At the time of the Franco-Prussian War, Bonvin travelled to London with his companion Louison Köhler (1850-1935). During the year he remained there, his financial problems increased. Returning to France in 1871, he settled in Saint-Germain-en-Laye (a small village outside Paris) and continued to exhibit at the Salons, often using Louison as model. Failing health eventually forced him to curtail his travels — he made one last trip to Holland in 1873 — but he continued to paint familiar scenes and everyday objects. Even though he had received official recognition in 1870, and continued to receive support from the young art dealer Gustave Tempelaere, his works in the 1880s attracted little notice except from the most fervent advocates of the Realist aesthetic. Belatedly, Bonvin's friends recognized his deplorable financial and physical condition, and a special charity exhibition and sale was organized and held a few months before his death in 1887.

Bibliography
Moreau-Nélaton, Etienne. *Bonvin raconté par lui-même.* Paris: H. Laurens, 1927.
Weisberg, Gabriel P. "François Bonvin and an Interest in Several Painters of the Seventeenth and Eighteenth Centuries." *Gazette des Beaux-Arts* 76 (December 1970): 357-66.
————. "François Bonvin and the Critics of His Art." *Apollo* 100 (October 1974): 306-11.
————. *François Bonvin: La Vie et l'oeuvre.* Paris: Editions Geoffroy Dechaume, 1979.

Eugène Boudin [14]
1824 Honfleur — 1898 Deauville

Although he was a self-trained artist and continued to work on his own throughout his career, Eugène Boudin is considered an important exponent of "open-air" painting. Boudin was first attracted to the artistic world in 1844 after he and a partner opened a framing and stationery shop in Honfleur, where Boudin also exhibited paintings of other young artists who were visiting the region to record light and atmospheric effects in landscapes. In this way, Boudin met Eugène Isabey, Constant Troyon, and Jean François Millet. Inspired by these contacts, Boudin started painting on his own until he received a subsidy from the Société des Amis des Arts in Le Havre in 1850, which permitted him to study in Paris. After the award expired, instead of remaining in Paris, Boudin returned to the Normandy coast and the work he preferred — painting directly from nature.

While painting in the region near Le Havre, Boudin discovered the early caricatures of Claude Monet (1858), and he encouraged this young artist to work outdoors. In 1859 Boudin met Gustave Courbet and the writer Charles Baudelaire, who were then visiting Le Havre. Boudin was later to receive Baudelaire's praise when he exhibited pastels at the 1859 Salon. During the early 1860s, Boudin made other contacts; he met Camille Corot, as well as Johann Jong-

kind, a painter who also did studies along the Normandy coast. Boudin divided his time between Normandy, Brittany, and Paris, completing studies of fashionable seaside resorts at Deauville or Trouville and similar works that distinguished him as a precursor of Impressionism. Participating in the first Impressionist show in 1874 increased Boudin's contacts with the younger avant-garde and convinced him to continue painting the sketchlike, atmospheric landscapes that would characterize his work for the remainder of his career. By 1883 Boudin's reputation was secured when he granted exclusive rights for the sale of his works to Durand-Ruel, the gallery dealer who held a successful exhibition of Boudin's paintings that year.

Although he was essentially a seascape and landscape painter, early in his career Boudin completed a series of still lifes. Inspired by an interest in Chardin, Boudin may have copied works by the eighteenth-century painter when Chardin's canvases were shown in the Louvre in the 1850s. Boudin was also interested in other still-life traditions, and there exist copies after Frans Snyders (Musée de Caen) and Hondecoeter (Musée de Caen) that document Boudin's knowledge of Dutch and Flemish painters. His independent canvases, however, reveal that his arrangement of forms and his choice of motifs (e.g., dead game) were, for the most part, inspired by Chardin [34].

Bibliography

Schmit, Robert. *Eugène Boudin: 1824-1898.* 3 vols. Paris: Imprimerie Union, 1973.

Adolphe-Félix Cals [15]

1810 Paris — 1880 Honfleur

An important early member of the Realist tradition, Adolphe-Félix Cals began exhibiting at the Salons in 1835 when he showed three canvases, including one with strong social implications (*A Poor Woman*). Cals's inclination toward paintings with societal commentary had been conditioned by his own impoverished background. While it is not known exactly when Cals became interested in art, he received his earliest training

from unknown printmakers and artists who taught him engraving, drawing, and how to work from plaster casts in the studio. After training with such men as Anselin, Ponce, and Bosc, Cals was introduced to the academic painter Léon Cogniet and entered his atelier at the Ecole des Beaux-Arts during the late 1820s.

Cogniet recognized the talents of his young pupil but found Cals's independent turn of mind disconcerting. Cogniet's impact, therefore, may have been cursory, except that his interest in meticulous realism inspired in Cals a need to adapt his own style toward themes which stressed the miserable existence of the lower classes. After his first exhibition at the Salon in 1835, Cals continued to show regularly at these yearly exhibitions until 1870. His works were often poorly hung (perhaps in less prominent locations) and received little notice by contemporary academic critics, who were uninterested in his genre scenes, landscapes, and/or compositions with provocative societal overtones.

Cals became associated with a number of the Realists (e.g., Bonvin, Ribot), so that by the time of the Salon des Refusés in 1863 he, too, was listed among the outspoken revolutionary figures in French painting. That year he exhibited a lower-class genre theme that depicted the work of a shoemaker — one of the many minor craftsmen who were being studied by the Realist artists as representative of honest, hard work. Cals's interest in the newer tendencies in French art led to a modification in his style according to innovative theory and painting technique. By 1874, six years before his death, he took part in the first independent exhibition of the Impressionists, showing a freer brushstroke and a lightened color range appropriate to the new generation of Realists who had emerged as a force on the art scene.

Cals's career as a painter was supported and advanced by his close friendship with the art dealer Père Martin. Martin — a man of passionate dedication and a strong proponent of direct, contemporary examination of environment and themes of humanity — first opened a shop in 1848 on the rue de Mogador, and later on rue Laffitte, where he sold paintings by Millet, Corot, and

others. Here, Martin was able to sell works by Cals for modest prices, assisting the painter at a crucial time in his career. In the process, Martin himself became a leading example of the new type of art patron: the energetic, dedicated art dealer who championed independent, progressive painters not associated with the academic system. With Martin's sponsorship, works by Cals thus entered private collections of the middle class, who appreciated his humble themes and, especially, his still lifes.

Père Martin was not the only individual to come to Cals's assistance. In 1858, after becoming acquainted at Martin's gallery, Count Doria and Cals formed a lifelong friendship that enabled Cals to work freely at Doria's private villas (until 1869), where he achieved some of his purest studies of light and atmosphere. In 1873 Cals moved to Honfleur to live with his friend the Dutch pre-Impressionist Jongkind; there he became associated with other painters who had been extensively studying atmosphere and light since the mid-1840s. His knowledge of canvases by the Barbizon painter Daubigny and of seascapes by Boudin increased Cals's awareness of other artists' studies that revealed the variations of differing times of the day.

It is Cals's earliest canvases, however, that merit further examination, since he first attracted attention in a variety of genre themes. His interest in still life, while apparently not extensive, began in the late 1840s, suggesting that he had an opportunity to study works by Chardin during the time they were first being rediscovered. Cals may thus be designated as among the first of the Realist painters to reexamine the master.

Bibliography

Alexandre, Arsène. *A. F. Cals, ou le bonheur de peindre.* Paris, 1900.
Delestre, François. *A. F. Cals, 1810-1880,* exh. cat. Paris: Galerie François Delestre, 1975.
Lafond, Paul. "Petits Maitres oubliés, Adolphe-Félix Cals." *Gazette des Beaux-Arts* I (3 per. 1898): 251-61.

Sören-Emil Carlsen [16]
1853 — 1932

As the leading American exponent of the Chardin revival, Sören-Emil Carlsen was influenced by Parisian still-life painters such as Antoine Vollon and Edouard Manet. Working in Paris in the middle 1870s, Carlsen had the opportunity of practicing the spontaneous paint application advocated by Vollon (who was then becoming quite prolific and popular) as well as absorbing the off-center compositional arrangements initiated by Manet in his still lifes.

After his first visit to France, Carlsen returned to the United States to become part of the New York art world and to work on still lifes and landscapes that reflected his interest in the Barbizon school. Carlsen returned to Paris in late 1875 to continue his study of the works of Chardin. He divided his time between the two continents, gaining inspiration from French masterpieces that he saw in the Louvre and in private collections. More than any other American painter, Carlsen captures the eighteenth-century master's tranquil mood and subtleties in form and light. Carlsen's paintings, however, characteristically show a higher tonal range because of his appreciation of Vollon and his thorough familiarity with the paintings of the Impressionists.

Many of Carlsen's works make use of an off-center arrangement of forms suggestive of the asymmetrical organization found in Oriental images. Thus, Carlsen introduced design principles that were adopted by other painters in America (such as William Merritt Chase, who was Carlsen's major rival in still-life painting).

Eugène Carrière [17]
1849 Gournay, Seine-et-Marne — 1906 Paris

When Eugène Carrière encountered art in the Louvre in 1869, he resolved to become a painter and entered the studio of Cabanel at the Ecole des Beaux-Arts. Carrière first supported himself through commercial lithography and after the Franco-Prussian War was befriended by the printmaker Jules Chéret in 1872/73. Like many artists in the nineteenth century, Carrière developed numerous painting themes, including still life.

During the 1870s Carrière completed paintings in a subdued Naturalist style that was influenced by Jean François Millet and Théodule Ribot. In 1876, Carrière failed to receive the Prix de Rome, but he was able to exhibit for the first time in the official Salon with a portrait of his mother. In 1879, he exhibited his first *Maternité,* and he remained faithful to this type of family theme throughout his career. He enjoyed painting his wife and children, using earlier Realist compositional arrangements. His interest in still life, usually of a few simple, familiar objects, relates to the intimacy Carrière achieved in all his mature work.

Throughout the 1880s Carrière exhibited an increasing number of works at each yearly Salon. These were studies of his children and family life that conveyed symbolic meanings and interpretations by making use of limited color, vague forms, and a misty, or *sfumato*-like, atmosphere to create a sense of mystery that appealed to the Symbolists. Because of his friendship within the Symbolist camp (e.g., Edmond de Goncourt and Paul Verlaine), Carrière's images that stressed moods of introspection and meditation became increasingly well known.

Carrière became a force in early twentieth-century art, and probably an influence on Matisse and the early works of Picasso. A large retrospective exhibition of his work was organized at the Ecole des Beaux-Arts (1907), where a few of his still lifes were shown and acclaimed because of their abstract compositional design.

Bibliography

Desjardins, Paul. "Artistes contemporains: Eugène Carrière." *Gazette des Beaux-Arts* 37 (April 1907): 265-76; 38 (July 1907): 12-26.

Geoffroy, Gustave. *L'Oeuvre de Eugène Carrière.* Paris, 1899.

Alexandre-Gabriel Decamps [18, 19]
1803 Paris — 1860 Fontainebleau

Alexandre-Gabriel Decamps, like other members of the Realist tradition, came from humble origins. When he was about fourteen he studied with the painter Etienne Bouhot; and, in 1818, he entered the studio of the academic painter Abel du Pujol. In the latter's studio he met the animal and genre painter Godefroy Jadin, who remained his lifelong friend.

After an introductory period in the 1820s, during which Decamps experienced some success, he made his debut at the Salon of 1827/28, and continued to exhibit regularly at the Salons until 1855. He received all the major awards of his time, and during the 1830s was thought to embody both Realist qualities and aspects of Romanticism. The most important moment in his career came in 1855, when, along with Delacroix and Ingres, he was given a large, retrospective exhibition at the World's Fair.

Although Decamps did all types of compositions throughout his career, he is best known for his Oriental themes. He created a vogue for images of Oriental daily life, and his name is associated with this movement. During the 1850s, when Decamps was no longer regarded by critics as among the progressive painters of the time, he experienced a personal decline. He refused to submit works to the Salons, shutting himself away in his home in Fontainebleau. While he became acquainted with some members of the Barbizon groups (e.g., Diaz, Corot), his relationship with younger painters (e.g., Jacques, Troyon) was not as close as generally believed. Withdrawing more and more into himself, Decamps illustrated the *Fables choisies* of La Fontaine, commented on the miserable working conditions of the poor, and produced occasional still lifes to decorate his dining room at Fontainebleau. These were the only still lifes he is known to have completed, and they were not formally exhibited during his lifetime.

With his health declining as well, Decamps refused to run for a seat in the Académie des Beaux-Arts (1856). Recognized by the royal family during the Second Empire, Decamp's official career was unfortunately cut short when he died

in a riding accident in the Fontainebleau Forest.

Bibliography

Mosby, Dewey. *Alexandre-Gabriel Decamps: 1803-1860.* 2 vols. Ph.D. diss., Harvard University, 1973; New York: Garland Publishers, 1977.

Henri Fantin-Latour [20]

1836 Grenoble — 1904 Burne, Orne

Henri Fantin-Latour occupies an important position in the evolution of Realism and in the continuation of Romanticism in the latter half of the nineteenth century. The son of a painter of portraits and religious subjects, Fantin-Latour continued this preoccupation in his own work, becoming one of the most eminent portrait painters during the Third Republic. When he was six, his family moved to Paris, where the young boy received an early, thorough training in drawing from his father. By 1850, Fantin-Latour entered the Ecole de Dessin where he studied under Horace Lecoq de Boisbaudran, a teacher of strongly independent concepts who trained the youth to intently observe what was before him and to work from memory. Fantin-Latour relied upon both of these skills when he did still lifes or portraits as well as Romantic scenes of classical figures in landscapes derived from his imagination.

Although he was denied entrance to the Ecole des Beaux-Arts (1854), Fantin-Latour determined to use standard, academic methods. He began copying, a method considered central to academic instruction, working from paintings in the Louvre and Versailles between 1853 and 1870. His apprenticeship was thorough; Fantin-Latour copied old masters of the Italian Renaissance as well as Dutch painters of the seventeenth century. During the late 1850s he became the friend of a number of younger painters, the second-generation Realists, and was invited to exhibit in the studio of François Bonvin when his 1859 Salon entries were rejected by the official jury. Exhibiting with Fantin-Latour were his comrades: Antoine Vollon [27-32], James

McNeill Whistler, and Théodule Ribot [25]. Whistler was a great influence, introducing Fantin-Latour to England, where he was to find ready and substantial patronage — especially for his still lifes. Although Fantin-Latour moved in progressive circles during the 1860s, he was also interested in the evolution of Romanticism, completing his first group portrait (1863) as an *Hommage à Delacroix.* Influenced as well by the works of Courbet, Fantin-Latour completed *Studio in the Batignolles* (1870) in which he used qualities of realism to indicate his support of Edouard Manet as the leader of independent painting.

During the 1860s Fantin-Latour's reputation as a portraitist and a still-life painter (essentially of flower arrangements) increased, providing him with a steady, albeit modest, income. While Fantin-Latour sympathized with the newer painting tendencies, he was determined to exhibit only in the official Salons and refused, along with Manet, an opportunity to exhibit with the Impressionists (1874). Always interested in discerning the "truth," Fantin-Latour intently studied nature, carefully recording nuances of light and texture in a style that became increasingly restrained and photographic. He regarded his still lifes as a means of earning a living, although they were exceptionally well prepared, utilizing traditions from the *trompe-l'oeil* devices of the Dutch painters of the seventeenth century.

Bibliography

Jullien, Adolphe. *Fantin-Latour, sa vie et ses amitiés; lettres inédites et souvenirs personnels.* . . . Paris: L. Laveur, 1909.

Eugène Lepoittevin [21]

1806 Paris — 1870 Auteuil

Eugène Lepoittevin is one of the least known painters of the second-generation Romantic school that came to maturity during the 1830s. Essentially a painter of marine scapes and small genre scenes, Lepoittevin first exhibited at the 1831 Salon, where he showed eight works. Lepoittevin was among the artists who travelled along the coast of France, drawing seascapes and

studying atmospheric conditions; but he also worked in England, making small studies of fishing villages and coastal inlets. By the mid-1840s Lepoittevin's career was well established, and he had received medals in numerous Salons (1831, 1836, 1848, and 1855). He obtained the Légion d'honneur in 1843. Further travels to Italy and the Netherlands increased his interest in the landscape tradition, which he developed in moody scenes of rivers and waterways.

Little is known of his interest in still life. He may have done a number of examples as part of a general interest in picturesque theory, since his studies of fish and fruits can be considered another aspect of the small genre scene.

David Emil de Noter [22, 23]

1825 Ghent — ?

David Emil de Noter was acquainted with artistic tradition since his father, Jean Baptiste André de Noter, was a landscape painter. Active in Brussels and Algiers, Noter exhibited not only in his native Brussels (ca. 1845) but at the Paris Salons beginning in 1853. He received a gold medal in Brussels in 1854. Noter was involved in printmaking, contributing to the growing interest in this medium during the middle decades of the nineteenth century. During the 1850s, he turned to still life and made his painting reputation from a series of small works based, in part, on an examination of Chardin examples, which were then being collected by artists and amateurs in Paris.

Germain Ribot [24]

1845 Paris — 1893 Paris

Germain Ribot was instructed at first by his father, who was also an artist, and then later by Antoine Vollon, from whom he received training in the composition of still life. His first Salon exhibition was in 1875, and he continued to show works throughout the 1870s.

Except for these exhibitions, little is known of Germain's work. He remains a shadowy figure

who — along with his sister Louise (1857-1916) — may have helped in the completion of some of his father's canvases. His still lifes are rare, although he may have completed many, considering his training and inclination.

Théodule Augustin Ribot [25]
1823 Saint-Nicolas-d'Attez (Eure)
— 1891 Colombes

Increasing interest in the French Realist-Naturalist movement has led to a reappraisal of Théodule Ribot. Long regarded as a latecomer to the Realist scene that affected French painting following the 1848 Revolution, Ribot became immersed in several mid-century movements: the revival of still-life painting; the etching renaissance of the 1860s; and the examination of themes drawn from environment and personal experience.

Despite a difficult life burdened by many family hardships, Ribot managed to train himself as an artist. After his father died in 1840, he found a low-paying job as a bookkeeper for a textile firm in Elbeuf (near Rouen), which enabled him to support his mother and sisters. In 1845, after his marriage and because he wanted a better job, Ribot went to Paris. At first, he worked for a mirror manufacturer, decorating gilded frames. Nevertheless, the serious interest in art that had begun when he was a young boy persisted, and somehow he managed to work in the atelier of Auguste-Barthélémy Glaize (1807-1893), his only known master. Here he studied the nude and assisted his teacher by perfecting architectural backgrounds in Glaize's paintings.

The exact chronology of Ribot's activities during the late 1840s cannot be determined because this period was interrupted by a three-year stay in Algeria where Ribot worked as a foreman. Both before and after his return to Paris (1851), Ribot struggled to make ends meet. He colored lithographs, decorated window shades and curtains, painted trade signs, and copied the work of Jean-Antoine Watteau (1684-1721) for American export. These commercial projects provided him with enough money to live on, but did not permit him to express his own talents.

The canvases Ribot completed in the late 1850s were painted by lamplight in the evenings at his home and were derived from his own environment. These works emphasize dark and light tonalities — aspects of his style imposed by inadequate light conditions, but a style which he continued to perfect throughout his career. Although his work was rejected at the Salons during the late 1850s, Ribot found a supporter in François Bonvin [10-13], who in 1859 exhibited Ribot's work in his own atelier, along with canvases by Antoine Vollon [27-32], Henri Fantin-Latour [20], and James McNeill Whistler (1834-1903).

In 1861 Ribot was finally accepted at the Salon. Several of his canvases depicted cooks, a theme also used by Bonvin that was then attracting Parisian collectors. Public awareness of his work increased as he exhibited at the annual Paris Salons; at international exhibitions; and provincial shows (Bordeaux, Lille, Rouen, Grenoble, Lyons, and Le Havre). Some artists and collectors during this period recognized his still lifes, genre scenes, and portraits as furthering the tradition of Realism. Ribot was also accepted by the official art establishment with two Salon medals he received in 1864 and 1865. The purchase of his *Saint Sebastian* by the Second Empire for 6000 francs in 1865 demonstrated that peasant types could be used in a religious scene if the work recalled similar masterpieces from the seventeenth century (e.g., the work of the Spanish painter José de Ribera [1591-1652]).

During this same period, Ribot also exhibited paintings in Parisian galleries, such as the gallery of Louis Martinet, a sympathizer with the independent Naturalist artists, and at the shop of Alfred Cadart, a patron of etching during the 1860s. In both locations, Ribot's works were hung with those by Bonvin and Edouard Manet (1832-1883).

Besides selecting themes from everyday life and popular literature, Ribot helped establish tonal painting. By using modulated tones of tan, gray, white, and black, Ribot created canvases or nuances reminiscent of the works of Frans Hals (1581/5-1666), in whom interest was then being revived. In modulating his dark and light scheme, Ribot worked within a limited color range that also suggests another source — the Spanish painters of the seventeenth century.

Few of Ribot's early canvases have been located. During the Franco-Prussian War (1870), he maintained a studio in the Parisian suburb of Argenteuil; but when the Prussians invaded this village and found his atelier, they destroyed many of his works. After Ribot moved to the small village of Colombes in the late 1870s, he suffered a severe illness which prevented him from painting for a time. Later, supported by a friend who eased some of his financial problems, Ribot devoted himself to painting genre scenes and numerous portraits of family and close friends in a style suggestive of Rembrandt.

In 1878, Ribot was inducted into the Légion d'honneur. At a special dinner held in 1884, his artistic contribution was recognized and he was presented with a medal of honor inscribed *A Théodule Ribot, le peintre indépendant*. This presentation by such well-known figures as Fantin-Latour, Bastien-Lepage, Jean-Charles Cazin, Alfred Stevens, J. F. Raffaelli, Joseph de Nittis, and Claude Monet documents Ribot's link with younger Naturalist painters.

The first important exhibition of Ribot's work took place in 1880 in a gallery belonging to the periodical *L'Art* (1880); major exhibitions were also held at the gallery of Bernheim-Jeune in 1887 and 1890. He was honored again when he was made Officer of the Légion d'honneur in 1887.

A year after his death, a large retrospective exhibition held at the Ecole des Beaux-Arts emphasized Ribot's contribution at a time when many younger painters were repudiating artists of the Realist tradition because of their preference for dark tones.

Little of Ribot's personal life is known. There are no descendants, and letters and other documentary material are sparse, which makes reconstruction of his career difficult, especially since he seldom dated his paintings. Thus, most of the information on Ribot's life and work has been provided only by standard sources. In addition, the archives of André Watteau (Paris) are invaluable in establishing a visual chronology for Ribot's work.

Bibliography

Fourcaud, Louis de. *Théodule Ribot, sa vie et ses oeuvres*. Paris, 1885.

Véron, Eugène. "Th. Ribot Exposition générale de ses oeuvres dans les galeries de *L'Art*." *L'Art* XXI (1880): 127-31, 155-61.

Weisberg, Gabriel P. "Théodule Ribot: Popular Imagery and *The Little Milkmaid*." *Bulletin of The Cleveland Museum of Art* LXIII (October 1976): 253-63.

Philippe Rousseau [26]

1816 Paris — 1887 Acquigny (Eure) Figures 19-21

Little is known about the life and work of Philippe Rousseau. Some biographers mention that he studied under Gros and Bertin, but others say that, like his friend François Bonvin, he was largely self-taught. Exhibiting first at the Salon of 1834, Rousseau did a series of landscapes from actual observation of the Normandy countryside. He continued to exhibit at the Salons until 1877 with a series of still lifes and allegorical images derived from the fables of La Fontaine. It was not until 1845, however, that Rousseau won his first medal — a third-class award for his *City Rat and Country Rat*. He received a first-class medal in 1848 and another as late as 1878.

One of his first still lifes, a theme for which he gained popularity, is now in the museum in Louviers and demonstrates his early awareness of the works of Oudry. During his career he also became a student and collector of the works of Chardin — an artist with whom he was often compared. By 1867, he completed *Chardin and His Models,* a work shown at the Salon but which unfortunately is now lost.

The critic Théophile Gautier in 1861 recognized Rousseau as a member of the Realist circle and praised his intense Romantic color, but Rousseau also studied the masters of the seventeenth century. His still lifes echo such Dutch masters as Pieter Claesz, Jan de Heem, and Wilhelm Kalf. Nonetheless, it was always with Chardin that Rousseau was compared, especially at his death when the press referred to him as the modern incarnation of the eighteenth-century painter.

Antoine Vollon [27-32]

1833 Lyons — 1900 Paris Figures 30, 35, 36, 43

As an exponent of the Romantic tradition of painting, Antoine Vollon became one of the most successful painters of the century. Vollon's fame rested largely on his still lifes, a number of which he completed for official patrons and private collectors during the 1880s and 1890s. These compositions often depict vessels and materials from his own studio, objects which Vollon used again and again to fulfill the insatiable demand for a canvas with his signature. Undoubtedly, the popularity of Vollon's work hampered completion of first-rate canvases; it cannot, however, detract from his considerable talent as an imaginative painter who, at his best, combined Realist and Romantic qualities.

Vollon began his career in Lyons, where he gained experience as an engraver. Between 1850 and 1852 he studied at the Ecole des Beaux-Arts in Lyons, winning awards in printmaking. Simultaneously, he continued his family's tradition of working in the industrial arts, copying masters of the eighteenth century for decorative art pieces. By 1858 he was exhibiting oil paintings in Lyons, and revealing an already-broad knowledge of previous painters from the seventeenth and eighteenth centuries.

Because of his success in Lyons, in 1859 Vollon moved to Paris, where he lived in poverty, making friends with Bonvin and Ribot and becoming associated with the second-generation Realist painters. He also sought assignments from the government of the Second Empire, requesting the opportunity to copy one of the Louvre masterpieces (July 1860). Having received the endorsement of such painters as Charles Daubigny (1817-1878), Hippolyte Flandrin (1809-1864), and Joseph Soumy (1831-1863), Vollon eventually received authorization to copy a work by the Spanish master Ribera (21 June 1862).

By 1864 two of Vollon's genre works were accepted at the Salon, one of which, a *Kitchen Interior,* was purchased by the state for 1800 francs. In these early works, including another *Kitchen Interior* (Nantes) shown at the Salon of 1865, Vollon displayed a knowledge of both Dutch sources and the still lifes of Chardin.

Throughout the 1860s Vollon received other state purchases (*Curiosities,* 1868; *Fish of the Sea,* 1870), although his period of greatest productivity occurred after the Franco-Prussian War. Vollon did landscapes and genre scenes in addition to still lifes, demonstrating his awareness of the Barbizon school and the Impressionist movement. His major contribution to the evolution of nineteenth-century painting, however, was his still lifes, which reveal a Romantic temperament combined with Realist studies of light and form. He received the Légion d'honneur in 1870.

Bibliography

Weisberg, Gabriel P. "A Still Life by Antoine Vollon: Painter of Two Traditions." *Bulletin of The Detroit Institute of Arts* 56, no. 4 (1978): 222-29.

Catalog

1 Abraham H. van Beyeren, Dutch, 1620/21-1690. *Still Life with a Silver Wine Jar and a Reflected Portrait of the Artist*. Oil on canvas, ca. 1655, signed, lower left: ABF, 39¼ x 32½ inches (99.7 x 82.5 cm.). Purchase, Mr. and Mrs. William H. Marlatt Fund. 60.80

2 Thomas-Germain-Joseph Duvivier, French, 1735-1814. *Attributes of Sculpture and Architecture*. Oil on canvas, 24½ x 44 inches (62.3 x 111.8 cm.). Private Collection, New York.

3 Nicolas-Henry Jeaurat de Bertry, French, 1728-after 1796. *Instruments of Music*. Oil on canvas, 1756, signed and dated, 24 x 28⅜ inches (61 x 72 cm.). Musée Carnavalet, Paris.

4 Nicolas de Largillière, French, 1656-1746. *Partridge in a Niche*. Oil on canvas, signed lower left, 27¹⁵/₁₆ x 22¹³/₁₆ inches (71 x 58 cm.). Petit Palais, Paris.

5 Jean Baptiste Oudry, French, 1686-1755. *Hare and Leg of Lamb*. Oil on canvas, 38⅝ x 28⅞ inches (98.2 x 73.4 cm.). Purchase, John L. Severance Fund. 69.53

6 Henri Horace Roland de la Porte, French, 1725-1793. *Preparations for a Simple Lunch*. Oil on canvas, 36¼ x 28¾ inches (92 x 73 cm.). Musée du Louvre, Paris.

7 Anne Vallayer-Coster, French, 1744-1818. *Basket of Plums*. Oil on canvas, 1769, 14¹⁵/₁₆ x 18³/₁₆ inches (38 x 46.2 cm.). Purchase, Mr. and Mrs. William H. Marlatt Fund. 71.47

8 Joseph Bail, French, 1862-1921. *Still Life*. Oil on canvas, signed lower left: Bail Joseph, 9¼ x 5¾ inches (23.5 x 14.6 cm.). Collection of Mr. and Mrs. Henry Scherer, Jr., Avon, Connecticut.

9 Denis-Pierre Bergeret, French, 1846-? *Shrimp*. Oil on panel, signed, lower left, 5¼ x 8¼ (13.4 x 21 cm.). Collection of Mr. and Mrs. Noah L. Butkin, Cleveland, Ohio.

10 François Bonvin, French, 1817-1887. *Attributes of Music*. Oil on canvas, signed and dated 1863, 24¾ x 45¼ inches (62.9 x 115 cm.). Collection of Mr. and Mrs. Noah L. Butkin, Cleveland, Ohio.

11 François Bonvin. *Still Life with Asparagus*. Oil on canvas, signed and dated lower left: F. Bonvin 1881, 24¼ x 19¾ inches (61.6 x 50.2 cm.). Anonymous Loan.

12 François Bonvin. *Still Life*. Oil on canvas, signed and dated bottom left: F. Bonvin 1859, 39 x 31⅝ inches (99.1 x 80.3 cm.). Wadsworth Atheneum, The Ella Gallup Sumner and Mary Catlin Sumner Collection, Hartford, Connecticut.

13 François Bonvin. *Still Life*. Oil on canvas, signed lower right: François Bonvin, 7⅜ x 9⅝ inches (18.7 x 24.5 cm.). Wadsworth Atheneum, The Ella Gallup Sumner and Mary Catlin Sumner Collection, Hartford, Connecticut.

14 Eugène Boudin, French, 1824-1898. *Still Life with Rabbit and Game Bag*. Oil on canvas, ca. 1856-1860, signed lower right: EB, 28½ x 19¾ inches (72.4 x 50.2 cm.). Private Collection, U.S.A.

15 Adolphe-Félix Cals, French, 1810-1880. *Still Life*. Oil on canvas, 1858, signed and dated upper left: Cals 1858, 17¾ x 24 inches (45.1 x 61 cm.). Collection of Mr. and Mrs. Noah L. Butkin, Cleveland, Ohio.

16 Sören-Emil Carlsen, American, 1853-1932. *Still Life*. Oil on canvas, 1890, signed and dated lower left: Emil Carlsen Paris 90, 25¼ x 31³/₁₆ inches (64.2 x 79.2 cm.). Collection of Mr. and Mrs. Noah L. Butkin, Cleveland, Ohio.

17 Eugène Carrière, French, 1849-1906. *Still Life*. Oil on canvas, 13 x 16 inches (33 x 40.6 cm.). The Art Institute of Chicago, Gift of Ivan Loiseau.

18 Alexandre-Gabriel Decamps, French, 1803-1860. *Still Life*. Oil on canvas, 1858, initialed and dated lower left: DC, rev. 1858, 24⅜ x 14 inches (61.9 x 35.6 cm.). Collection of Mr. and Mrs. Noah L. Butkin, Cleveland, Ohio.

19 Alexandre-Gabriel Decamps. *Still Life*. Oil on canvas, 1855, initialed upper right: DC, Inv. 1855, 24¾ x 15 inches (62.9 x 38.1 cm.). Collection of Mr. and Mrs. Noah L. Butkin, Cleveland, Ohio.

20 Henri Fantin-Latour, French, 1836-1904. *Flowers and Fruit*. Oil on canvas, 1866, signed and dated upper left: Fantin 1866, 28¾ x 23½ inches (73 x 59.7 cm.). The Toledo Museum of Art, Gift of Edward Drummond Libbey.

21 Eugène Lepoittevin, French, 1806-1870. *Still Life*. Oil on panel, signed upper left: Lepoittevin, 13 x 9¾ inches (33 x 24.8 cm.). Collection of Mr. and Mrs. Noah L. Butkin, Cleveland, Ohio.

22 David Emil de Noter, Belgian, 1825-? *Still Life*. Oil on panel, initialed lower left: D.N., 5 x 7½ inches (12.7 x 19 cm.). Collection of Mr. and Mrs. Noah L. Butkin, Cleveland, Ohio.

23 David Emil de Noter. *Still Life*. Oil on panel, initialed lower left: D.N., 5 x 7¾ inches (12.7 x 19.7 cm.). Collection of Mr. and Mrs. Noah L. Butkin, Cleveland, Ohio.

24 Germain Ribot, French, 1845-1893. *Oysters and Partridges*. Oil on canvas, signed lower left: Germain Ribot, 18¼ x 21⅞ inches (46.4 x 55.6 cm.). Collection of Mr. and Mrs. Noah L. Butkin, Cleveland, Ohio.

25 Théodule Augustin Ribot, French, 1823-1891. *Still Life with Ceramics and Eggs*. Oil on canvas, signed lower left: T. Ribot, 20½ x 36½ inches (52.1 x 92.7 cm.). Anonymous Loan.

26 Philippe Rousseau, French, 1816-1887. *Asparagus*. Oil on canvas, 14 x 25½ inches (35.6 x 64.8 cm.). Inscribed lower left: "A son ami — A. Arago." Collection of Mr. and Mrs. Noah L. Butkin, Cleveland, Ohio.

27 Antoine Vollon, French, 1833-1900. *Still Life with Skull*. Oil on canvas, 13 x 18¼ inches (33 x 46.4 cm.). Collection of Mr. and Mrs. Noah L. Butkin, Cleveland, Ohio.

28 Antoine Vollon. *Still Life with Fish*. Oil on canvas, 29 x 27 inches (74 x 68.6 cm.). Collection of Mr. and Mrs. Noah L. Butkin, Cleveland, Ohio.

29 Antoine Vollon. *Still Life with Oysters*. Oil on panel, signed lower right: A. Vollon, 12¾ x 15⅞ inches (32.4 x 40.4 cm.). Collection of Mr. and Mrs. Noah L. Butkin, Cleveland, Ohio.

30 Antoine Vollon. *The Rabbit*. Oil on panel, signed lower left: A. Vollon, 19⁷/₁₆ x 14¹/₄ inches (49.5 x 30 cm.). Private Collection, U.S.A.

31 Antoine Vollon. *Monkey Cook*. Oil on canvas, signed lower left: A. Vollon, 24 x 19¹¹/₁₆ inches (61 x 50 cm.). Private Collection, U.S.A.

32 Antoine Vollon. *Still Life with Copper Cauldron*. Oil on canvas, signed lower right: A. Vollon, 15¹/₈ x 18¹/₁₆ inches (38.4 x 45.9 cm.). Private Collection, U.S.A.

33 Anonymous, French, ca. 19th century. *Still Life with Artichokes*. Oil on canvas, 18⅞ x 23 inches (48 x 58.5 cm.). The National Gallery of Canada, Ottawa.

List of Figures

Figure 19. Philippe Rousseau, French, 1816-1887. *The Black Hen*. Oil on canvas. 27⁹/₁₆ x 63 inches (70 x 160 cm.). Musée de Louviers.

Figure 20. Philippe Rousseau. *The Garden Bench*. Oil on canvas. 79 x 72 inches (200.7 x 182.9 cm.). Utah Museum of Fine Arts, Salt Lake City, Gift of Mrs. Richard A. Hudnut.

Figure 21. Philippe Rousseau. *The Fountain*. Oil on canvas. 79 x 72 inches (200.7 x 182.9 cm.). Utah Museum of Fine Arts, Salt Lake City, Gift of Mrs. Richard A. Hudnut.

Figure 22. Oscar Roty, French, 1846-1911. *Medal of Eudoxe Marcille*. Bronze, 1886. Private Collection, France.

Figure 23. *Portrait of Camille Marcille*. Oil on canvas. Private Collection, France.

Figure 24. François Bonvin, French, 1817-1887. *Woman Drawing Water*. Oil on canvas. 18 x 12¾ inches (45.7 x 32.4 cm.). Walters Art Gallery, Baltimore.

Figure 25. *Lithograph of Philippe Burty*. Lithograph, 1870. Cabinet des Estampes.

Figure 26. Edouard Manet, French, 1832-1883. *Still Life with Carp*. Oil on canvas. 28⅞ x 36¼ inches (73.4 x 92.1 cm.). The Art Institute of Chicago.

Figure 27. François Bonvin. *Still Life with Candlestick*. Charcoal drawing. 7½ x 5½ inches (19 x 14 cm.). Private Collection, Holland.

Figure 28. Armand Gautier, French, 1825-1894. *Still Life with Books and Glasses*. Oil on canvas. 10¹³/₁₆ x 19¹¹/₁₆ inches (27.5 x 50 cm.). Location unknown.

Figure 29. Paul Cézanne, French, 1839-1906. *Still Life with Bread and Eggs*. Oil on canvas. 23¼ x 30 inches (59.1 x 76.2 cm.). Cincinnati Art Museum, Gift of Mary E. Johnston.

Figure 30. Antoine Vollon, French, 1833-1900. *Still Life with Flower Pots*. Oil on canvas. 24⅝ x 19⅞ inches (62.5 x 50.5 cm.). Courtesy of A. Daber, Paris.

Figure 31. Léon Bonvin, French, 1834-1866. *Still Life: Vase of Flowers*. Water color, 1863. 6½ x 8½ inches (16.5 x 21.6 cm.). Walters Art Gallery, Baltimore.

Figure 32. Gustave Caillebotte, French, 1848-1894. *The House at Gennevilliers*. Oil on canvas. 46 x 35⅛ inches (116.9 x 89.2 cm.). Private Collection, U.S.A.

Figure 33. Anne Vallayer-Coster, French, 1744-1818. *Still Life with Game*. Oil on canvas, 1782. 28 x 35¼ inches (71.2 x 89.5 cm.). The Toledo Museum of Art, Gift of Edward Drummond Libbey.

Figure 34. Jean Siméon Chardin. *Wild Rabbit with Game Bag, Powder Flask, Thrush, and Lark*. Oil on canvas. 28¾ x 23⅝ inches (73 x 60 cm.). Private Collection, Paris.

Figure 35. Antoine Vollon. *Still Life with Game Birds*. Oil on canvas, 1864. 28 x 41 inches (71.1 x 104.2 cm.). Private Collection, Paris.

Figure 36. Antoine Vollon. *Trophy of the Hunt and Raisins*. Oil on panel. 37⅜ x 28⅛ inches (95 x 71.5 cm.). Private Collection.

Figure 37. Jean Siméon Chardin. *The Ray-Fish* (also called *Kitchen Interior*). Oil on canvas. 45⅛ x 57½ inches (114.6 x 146 cm.). Musée du Louvre.

Figure 38. Jean Siméon Chardin. *Attributes of the Sciences*. Oil on canvas, 1731. 55½ x 86⁷/₁₆ inches (141 x 217 cm.). Musée Jacquemart-André.

Figure 39. Jean Siméon Chardin. *Attributes of Civilian Music*. Oil on canvas, 1767. 44⅛ x 56⅞ inches (112 x 144.5 cm.). Private Collection, Paris.

Figure 40. Jean Siméon Chardin. *Attributes of Military Music*. Oil on canvas, 1767. 44⅛ x 56⅞ inches (112 x 144.5 cm.). Private Collection, Paris.

Figure 41. Jean Siméon Chardin. *Fast-Day Meal*. Copper, 1731. 13 x 16⅛ inches (33 x 41 cm.). Musée du Louvre.

Figure 42. Jean Siméon Chardin. *Meat-Day Meal*. Copper, 1731. 13 x 16⅛ inches (33 x 41 cm.). Musée du Louvre.

Figure 43. Antoine Vollon. *Still Life with Cauldron*. Oil on canvas. 26⅜ x 31⅞ inches (67 x 81 cm.). Private Collection, Paris.

Figure 44. Michel-Honoré Bounieu. *Preparations for a pot-au-feu*. Oil on canvas. 25³/₈ x 31¹¹/₁₆ inches (64.5 x 80.5 cm.). Musée du Louvre, M.I. 1047.

Themes in Art

This volume is one of a new series of books about art, art history, and artistic expression being published by the Art History and Education Department of The Cleveland Museum of Art under the general editorship of Dr. Gabriel P. Weisberg, curator of art history and education. The books listed here are also available now. Future titles include *Idea to Image: Preparatory Studies from the Renaissance to Impressionism* and *Chinese Paintings: Themes and Techniques*.

Between Past and Present: French, English, and American Etching 1850-1950 by Gabriel P. Weisberg and Ronnie L. Zokon. 76 pp., 8½ x 7¼ inches. 49 illus., 1977. LC 76-53113, ISBN 0-910386-33-1, $4.00.

In the Nature of Materials: Japanese Decorative Arts by Marjorie Williams. 48 pp., 8¾ x 11 inches, 33 illus., 1977. LC 76-51970, ISBN 0-910386-32-3, $4.00.

Materials and Techniques of 20th-Century Artists by Dee Driscole and Dorothy Ross, under the guidance of Gabriel P. Weisberg, Andrew T. Chakalis, Karen Smith, and June Hargrove. 48 pp., 7½ x 9 inches, 31 illus., 1976. LC 76-29167, ISBN 0-910386-37-4, $3.00.

The Public Monument and Its Audience by Marianne Doezema and June Hargrove. 72 pp., 62 b & w illus., 8½ x 7½ inches, 1977. NA9347.D63 730'.973 77-25428 ISBN 0-910386-38-2, $4.50.

A Study in Regional Taste: The May Show 1919-1975 by Jay Hoffman, Dee Driscole, and Mary Clare Zahler. 72 pp., 70 b & w illus., 8½ x 7¼ inches, 1977. LC 77-78145, ISBN 0-910386-36-6, $4.00.

The Artist and the Studio in the Eighteenth and Nineteenth Centuries by Ronnie L. Zakon. 68 pp. 40 b & w illus., color cover, 8½ x 7½ inches, 1978. LC 78-51885, ISBN 0-910386-40-4, $3.00.

American Folk Art: From the Traditional to the Naive by Lynette I. Rhodes. 120 pp., 88 b & w illus., 6 color plates, 8½ x 7¼ inches, 1978. LC77-9240, ISBN 0-910386-42-0, $7.95.